IMAGES
of England

NORTH SHIELDS

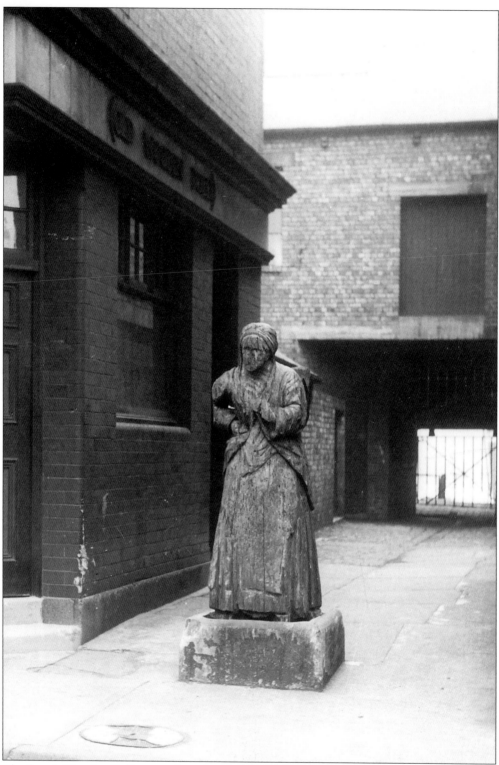

The fourth Wooden Dolly erected on this well known site.

IMAGES
of England

NORTH SHIELDS

Compiled by
Eric Hollerton

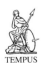

TEMPUS

Low Street, from the High Light, 2 October 1907.

First published 1997, reprinted 1999, 2001, 2002

Tempus Publishing Limited
The Mill, Brimscombe Port,
Stroud, Gloucestershire, GL5 2QG

British Library Cataloguing in Publication Data.
A catalogue record for this book is available from the British Library.

ISBN 0 7524 0730 9

Typesetting and origination by Tempus Publishing Limited
Printed in Great Britain by Midway Colour Print, Wiltshire

Contents

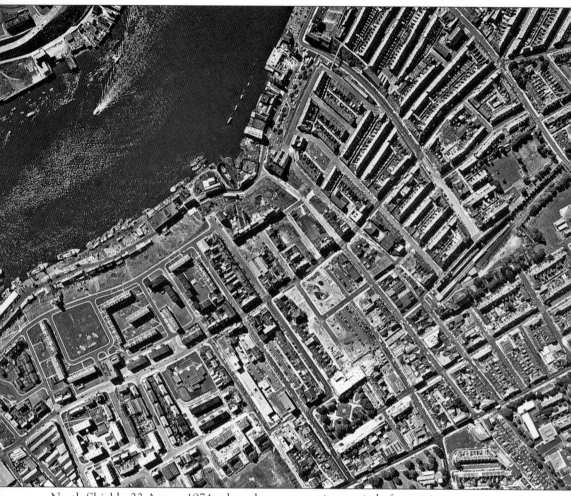

North Shields, 22 August 1974, when the town was in a period of transition.

Acknowledgements

Thanks are due to all those members of the public who provided information and illustrations to the Local Studies Centre of North Tyneside Libraries. Many of the photographs for which space was not found in the book still provided useful evidence in compiling the text. Contributors include; Mr Adams, Mr Amess, T.W. Armstrong, Mr Arnold, J. Bell, Mr Bertram, Mr Brunton, Mr Burt, Mrs Chambers, Miss Chater, Mr Clark, Mr Davies, Mr Dickson, R.T. Dix, Mr Goonan, Dr Gould, Mrs Grant, Mr Grey, Mr Grunson, Mrs Heather, Mr Hunter, Mrs Hunter, Mr Jasper, Mr Kidd, J.C. Lane, Mr McQueen, P. McVay, Mrs Mitchell, Mrs Pannell, Mr Reay, Mrs D.E.R. Rigby, Mrs S. Ross, M. Scott, Mr Shermer, J. Smurthwaite, W.H. Smurthwaite, Mr Stobbart, Mrs Stockdale, K. Sutton, B. Topping, J.B. West. Special thanks are due to the late Mrs Sadler, who donated the collection taken by her father, Mr Porter. Mention must also be made of the work of Roland Park, who recorded much of the old town for the Council.

Introduction

Around the year 1225 Prior Germanus of the monastery at Tynemouth began a village of shielings, or rude huts, in the valley of the Pow Burn. Initially they served the fishermen who supplied the Priory, but traders began to take advantage of the new landing place, so close to the mouth of the River Tyne. Soon a small port had grown and this aroused the jealousies of the established merchants at Newcastle. They began a series of legal and physical attacks which lasted for centuries. In 1290 it was claimed that North Shields was a town 'where no town ought to be', and that its existence was a loss both to the City and the Crown. On that occasion the Prior lost his case, but by the end of the century there were a hundred houses, many with their own quays.

Despite the determined efforts of the burgesses of Newcastle, the town clung to existence, until an Act of 1530 imposed considerable restrictions. This, and the Dissolution of the monastery on 12 January 1539, led to the decay of the town. The houses had been built at the foot of the bank, without land to provide alternative employment. With trade constrained, they could not be let, and fell into ruin. In 1655 brewer Ralph Gardner, of Chirton, wrote to Oliver Cromwell complaining of Newcastle's oppression. The map attached to his book shows a double row of buildings at the riverside, between the Durtwich Sand and the High Light. There is nothing at the Pow Dene, except for the Low Light, and the Banktop is open land. It was about this time that the use of cheap local coal to boil salt out of the river water became a major industry. It was said that the town could be seen from the Cheviots, identifiable by its pall of smoke and steam.

In 1757 a map of the Manor of Tynemouth shows the town in an unbroken line from the High Light to Milburn Place, with a few houses facing the Pow Burn. There was also a farm near the site of Charlotte Street, surrounded by narrow strips of fields. A few houses stood on the bankside and at Church Way, with cottages at the Ropery Banks. The Banktop was divided into relatively small areas, held by a number of landowners. To the east, much of the property descended to the Stephenson, Linskill and Dockwray families. The latter are credited with first laying out the land for speculative builders in 1763. The others followed suit. In 1796 the Earl of Carlisle sold much of the land which came to form the town centre, to John Wright. He named Norfolk, Howard and Bedford Streets in honour of the previous owners and laid out Saville Street. The Ordnance Survey found that considerable development had taken place by 1857. Most of the ground south of Tynemouth and Albion Roads had been built up, as far west as Little Bedford Street. Milburn Place occupied Edward Collingwood's land above the

Limekiln Shore.

A great rise in the shipping trade during the Napoleonic Wars increased the prosperity of the town. The long battle with Newcastle was virtually ended with the creation of the Port of Tyne in 1848, and the Tyne Improvement Commission in 1850. An appointed Commission brought limited local government to North Shields in 1828, replaced by the Borough of Tynemouth in 1849. The opening of the Northumberland Dock at Howdon, in 1857, led to a westward growth, in part over land belonging to the Waters family. Building was considerably increased when George Otto Trevelyan disposed of the Chirton Estate in 1869, which in turn encouraged the development of the Sibthorpe and Yeoman estates on the Ropery Banks.

By the mid 1850s North Shields was a port, a manufacturing town, and a retail centre serving a wide area. The rate of growth can be judged from the 1851 Census, which shows that most of the adults and many of the children were born outside the town. The Water Company was founded in 1786, and 1819 the Gas Company was established. In 1839 North Shields was at the terminus of the first public railway on Tyneside. The town was notable for a wide range of useful and improving organisations. Public education had been available since 1810. In addition to the provisions of the Poor Law, there were charities serving the sick and the disadvantaged. Descended from a number of mutual improvement societies, North Shields opened the first Free Library on Tyneside in 1870. There were problems, however. Many of the early properties had been perfectly acceptable in their day, but poor drainage and the dubious actions of the Water Company promoted outbreaks of cholera.

Tynemouth became a County Borough in 1904, with a growing range of powers. In 1914 they demolished some of the worst properties, and built the Balkwell Farm housing estate. Between 1933 and 1938 the Ridges Farm estate enabled the clearing of the banksides. In the custom of the day, great swathes of the town centre and East End were swept away in the 1960s, to be replaced in a bland style. Twenty years later the mood had changed. After years of planning blight, North Tyneside Council and the Tyne & Wear Development Corporation introduced architectural diversity, restoration and sympathetic building styles to the Dolphin Quays and the Union Square developments. Housing and employment began to return to the heart of the town.

This introduction is necessarily a simplified account. For further details readers may care to consult *England's Grievance Discovered*, by Ralph Gardner; *History of Shields*, by William Brockie; and *A History of Northumberland. The Parish of Tynemouth*, by H.H.E. Craster. Since 1974 North Tyneside Libraries have been collecting historical and current information in their Local Studies Centre. The contents of this book is drawn from their stock, and are offered in the hope that they will inform and entertain. The staff would be most grateful to hear of any errors or omissions.

One
Low Lights

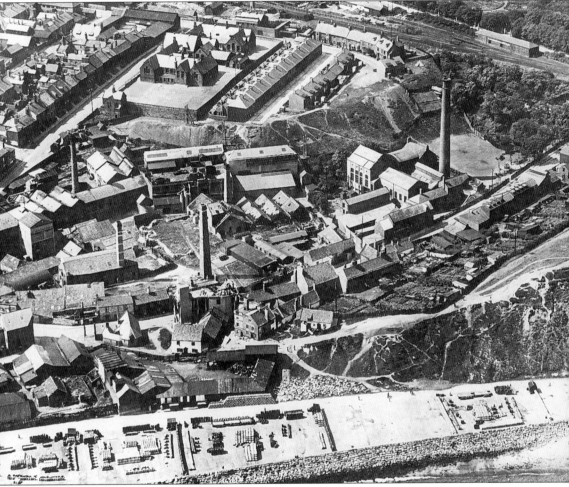

Pow Dene, c. 1935. At the top of the picture is the Eastern Board School, and below this the Fish Quay extension. Across the centre are the Tyne Brand factory, the guano works, and the power station on Tanners Bank. In 1901 the Tyne Brand factory, the long building to the left, opened there. The North Shields Fish Guano & Oil Works was founded in 1888, and was the origin of the North Shields Smell, a source of distress into the 1950s. The road down from the Tynemouth railway took its name from Richardson's tannery, founded in 1766. It closed in the 1890s, and after a spell as a saw-mill became the site of Tynemouth Council's electricity works, opened in 1901. The eastern extension to the Fish Quay was built to provide work in the Depression. It is laid out with barrels for salting fish. On the bank above, a pale track is the only vestige of the wagonway between Whitley Colliery and a staith at the Low Light, which ran down Union Road between 1810-1848.

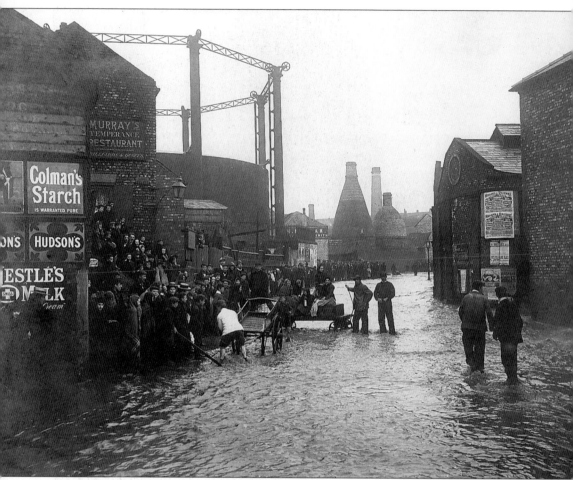

A crowd takes refuge on the steps of Murray's Temperance Restaurant, Union Road, 1900. Torrential October rains produced flooding around Tyneside, even on the hill leading down to the Low Street. The cabin in front of the gasholder housed Baker's barking tanks and opposite are posters for the Midland Railway. The gas works had been here since 1820. In the distance are the bottle kilns at Carr's pottery which was in the town between 1813 and 1913. It stood at the southern end of the area seen on p. 9.

Union Road, 1958. The lorry is outside Henry Horn & Sons, fish curers since the 1880s. Around the same time Alfred Freeth set up his ship chandlery. In the distance is the tower over Robert Hastie's, who started catching and selling fish at North Shields in the 1870s.

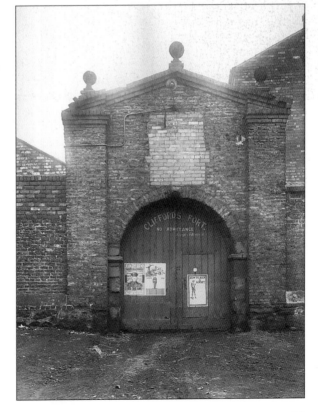

Clifford's Fort, 1927. Begun in 1672, to defend the harbour against the Dutch, it was probably named after the Lord High Treasurer, Thomas Clifford. From 1881 the Tyne Electrical Engineers used it to launch mines. It closed in 1928.

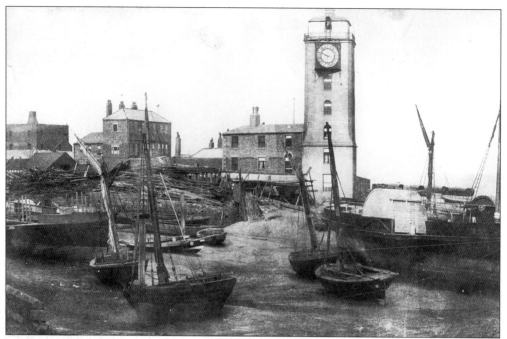

Low Light, c. 1855. The 1810 Low Lighthouse had at that time a short-lived tide-gauge. To the left the 1727 light has been converted to almshouses. At the extreme left is the citadel of Clifford's Fort, removed in 1893.

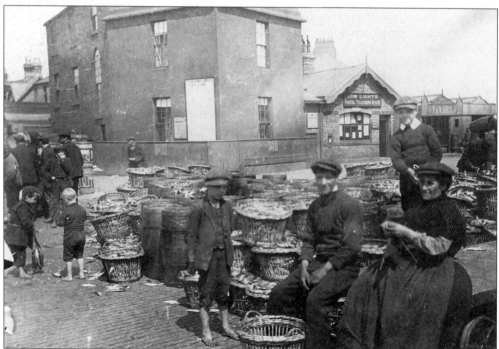

Fish Quay, c. 1910. To the right of the Low Light is the old lifeboat house, cut off from the river when the Council built this road in 1884. It became the telegraph office in 1888, and was later a cafe.

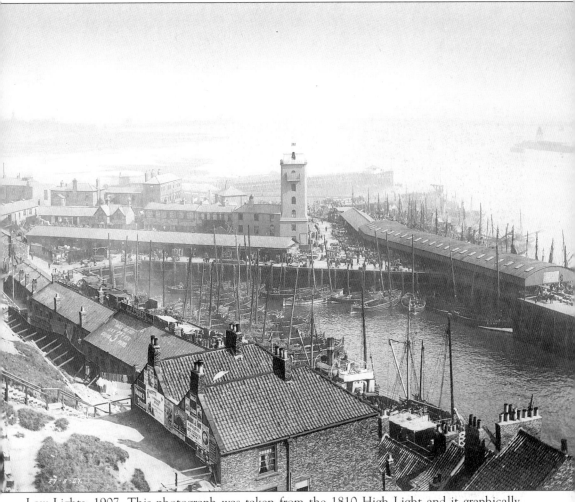

Low Lights, 1907. This photograph was taken from the 1810 High Light and it graphically illustrates how far the channel could shift. The Black Middens, in the distance, and shifting sandbanks made the Tyne a difficult river to enter. Leading lights were built in pairs, at the bank top and by the river's edge, to mark the safe channel. If the river shifted too much, new lights were needed. The building in the centre left, pointing out to sea, was built as a low light in 1727 and was later converted for accommodation by Trinity House of Newcastle. A number of schemes to build deep-water docks on the Black Middens came to nothing, leading Tynemouth Council to plan its Fish Quay. The first jetty ran out past the Low Light, opening in 1870. Although there were doubters the quay proved attractive to skippers from the north of Scotland to Yarmouth. Through the 1870s the Council extended the moorings along the Low Street, and in 1884 reclaimed part of the Sand End, behind the lighthouse. In 1895, when the range (waves or swell) from the sea was found to damage boats moored in tiers, the Protection Jetty was built. It enclosed the area known as the Gut.

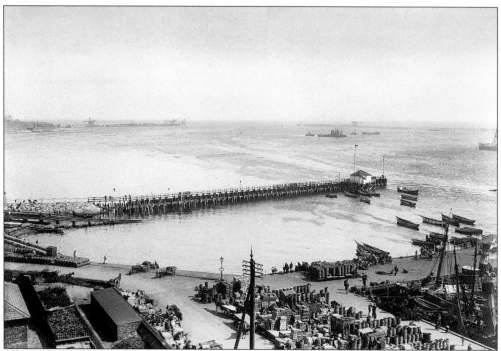

Lloyds' Hailing Station, c. 1907. Lloyds of London opened their watch house at the end of a jetty near the Quay in 1902, to record shipping movements. Until 1969 men stood at the end of the jetty to query passing vessels.

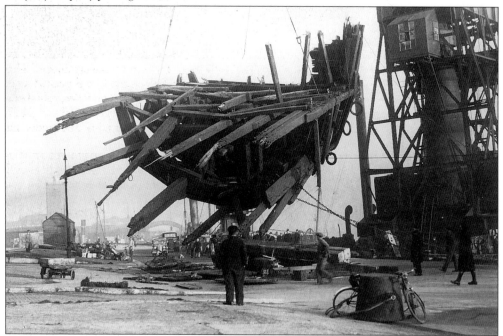

Fish Quay, 1938. Some shipping movements were a problem. On 22 November 1938 the 8000-ton Royal Star took a shear and drove into the Protection Jetty, smashing the timbers. Shortly before the accident the trawler *William Purdy* had been moored at this part of the quay.

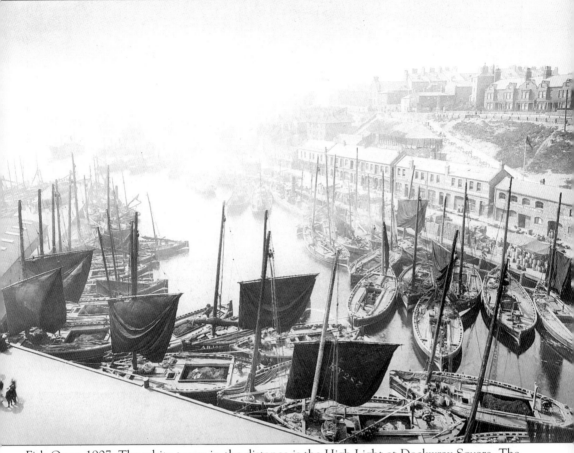

Fish Quay, 1907. The white tower in the distance is the High Light at Dockwray Square. The lamp-housing of its 1727 predecessor can be seen to the right. Below, the Gut is packed with fishing boats. Well into the twentieth century Scottish sailing craft, Zulus and Fifies, fished out of North Shields. Steamboats were used to get them to the fishing grounds quickly. In 1877 tugowner William Purdy fitted trawl-gear to the *Messenger*. He was credited with introducing steam trawling to the Tyne. (See also p. 30)

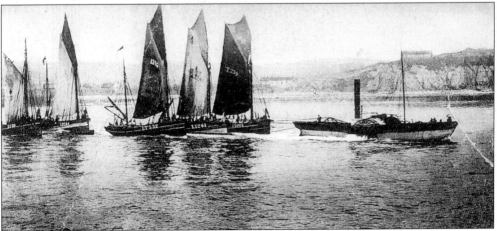

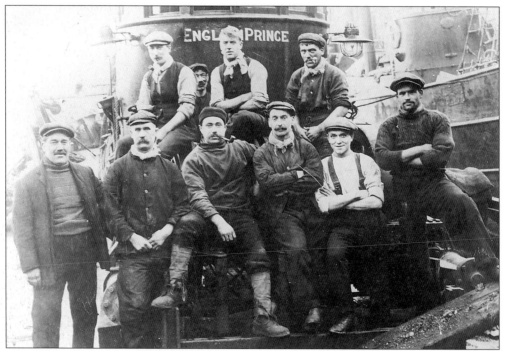

English Prince, c. 1900. William H. Storey, brother-in-law to Richard Irvin, began his fishing fleet with the *Saxon Prince* around 1885. At his death in 1903 he had twenty-three modern vessels known as the 'Prince boats'.

Fish Quay, February 1933. These anglers were celebrating the first codling. The man in the dungarees is William 'Ducky' Reed.

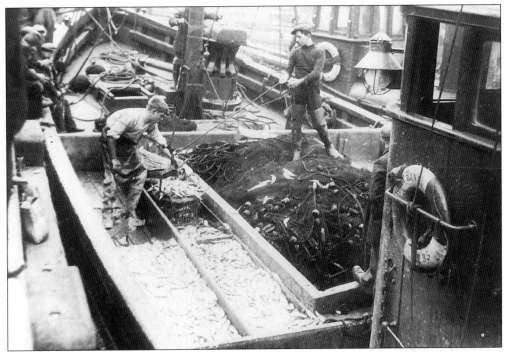

Landing herring, c. 1935. Steam revolutionised the industry and purpose-built fishing boats soon replaced converted tugs. At its height hundreds of vessels would sail from the Tyne, especially during the herring season.

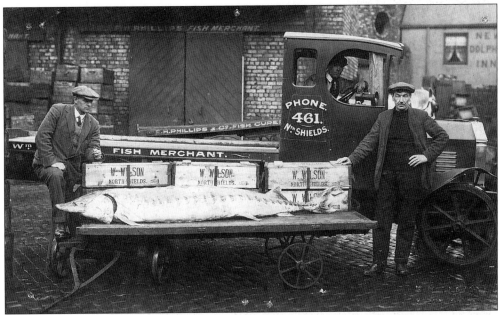

William Wilson, c. 1935. North Shields was famous for its herring, but salmon and a wide range of white fish were landed. There were even such exotics as tunny. William Wilson, standing to the right, displays a sturgeon.

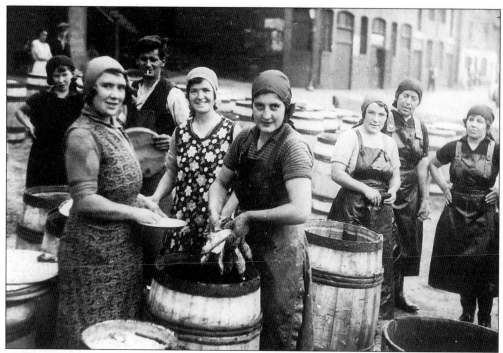

Salt herring, c. 1935. During the summer months vast shoals of herring swam south. The Scottish fleet followed them, as did a small army of fishwives who gutted and salted the fish, packing them in barrels.

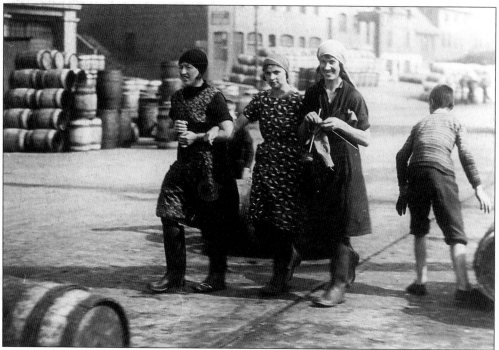

Fishwives, c. 1935. Even in their leisure time the Scottish girls were said never to be idle and they usually had a bundle of knitting about them.

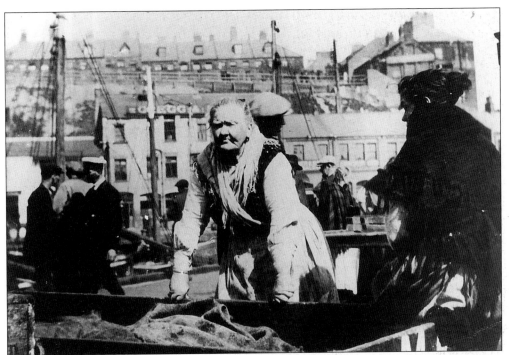

Fish Quay, c. 1920. The lady in the centre has been identified as Jane Ashley, who died in 1929. The man in the white cap is Tom Mackenzie junior. Father and son, the Mackenzies were quay masters for many years.

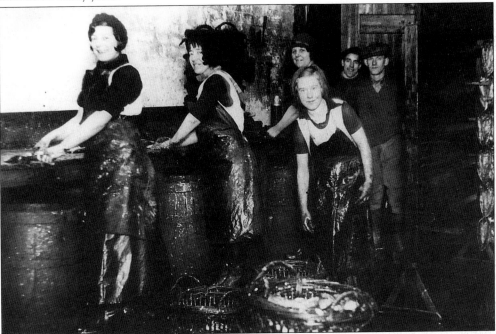

Smokehouse, c. 1936. The owner, Ralph Thurston, is on the right. Clair Reay is leaning over the basket, with May Malone to the far left. John Woodger claimed to have invented kippers in 1846. The Thurstons began around 1906.

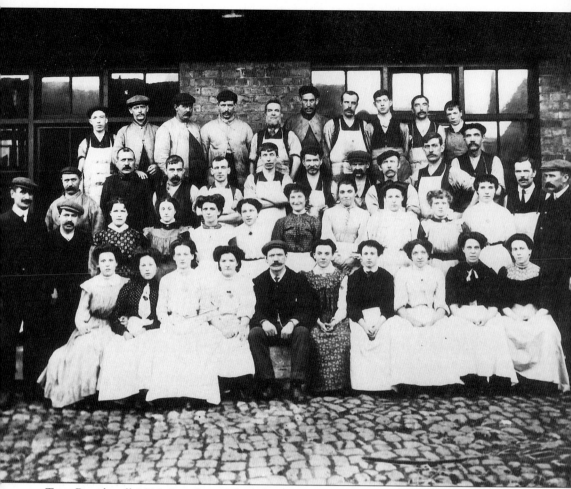

Tyne Brand staff, 1919. Standing at the left are Tom Gibb and Bill McKay. Davy Parker, Jimmy Gillies, and Tom Brand are second, third and fourth from the left in the top row. Jack Short is second from the right and Alec Hay is seated at the front. Set up in 1901 as the Shields Ice & Cold Storage Company, they began canning herring under the Tyne Brand label in 1903. During the First World War the company was directed to pack meat, soup and jam for the Forces. By the time of the photograph they were a household name. During the 1920s puddings were added to their range. Fish Quay pioneer Richard Irvin was one of the founders of the company, and when he retired in 1958 the new chairman, Harold Thompson, began a period of expansion. Lakeland Food Products, Henry Sutton, and St Aubin Brand were taken over, and a line of meat products was developed. The firm was sold to Spillers Ltd in 1967. They converted the North Shields factory to pet foods in 1973, but closed it three years later.

Two

Shipping

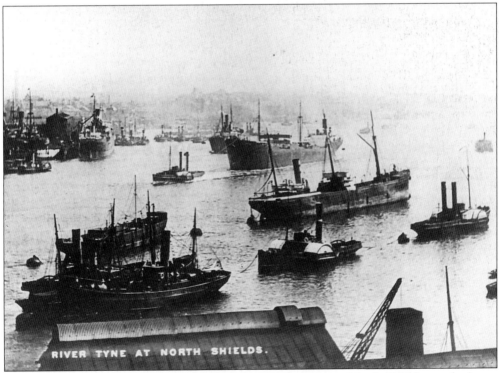

RIVER TYNE AT NORTH SHIELDS.

Shields Harbour, c. 1910. As a major industrial river the Tyne at North Shields was the home of, or gave passage to, a wide range of shipping.

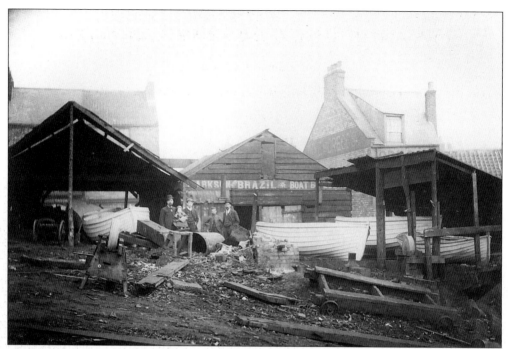

Clarkson & Brazil, c. 1895. Thomas Clarkson's partnership with his step-brother, Andrew Brazil, was short-lived. He held the Milburn Place boatyard until the turn of the century, then moved his business to Scarp Park, Clive Street.

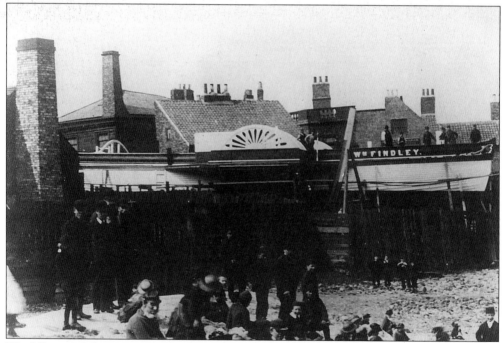

Wouldhave & Johnson, 1884. The tug *William Findley* was possibly the last launched at the Low Lights, just before the Fish Quay extension. Named after the engine builder's son, she was lost in 1922, working out of the Tees.

SMITH'S DOCK COMPANY LIMITED

1899—1949

NORTH SHIELDS EMPLOYEES WITH SERVICE EXCEEDING THIRTY-SIX YEARS

Smith's Dock, September 1949. All of these employees had at least 36 years with the firm. In the front row, left to right are, J. Morton, 50 years service; J.H. Matthews, 49; J. Armstrong, 52; A. Young, 52; S. Dack, 51; J. Morgan, 56; R.H. Stephenson, T. Eustace Smith, Sir G. Tristram Edwards, T.D. Straker-Smith, J. Patton; H.W. Welch; R. McVay, 59; H. Wright, 57; R. Smith, 57; W. Atkinson, 50; J. Garrard, 52; P. Skilleter, 42; R. Laing, 40; O. Nattrass, 40. T. & W. Smith of St Peter's began work on a glass-roofed shipyard at Milburn Place in 1849, although a dispute with their neighbours delayed the opening until 1852. Because there was so little space, they soon became experts in the use of pontoon docks. In 1884 Harry Edwards, of South Shields, took over Laing's graving dock at the Bull Ring and built three new docks on the site. His sons ran the small dock next door. When Mr Edwards died in 1898, a merger of the three firms was proposed. The new Smith's Dock Company demolished the area around Dotwick Street and greatly enlarged their site. Working on the new bulk oil carriers became a speciality. With the yards at South Shields, and Middlesbrough from 1909, Smith's Dock Company was able to boast of being the largest ship-repair concern in the world. As part of British Shipbuilders, they also ran the old Shields Engineering Dock on Liddell Street. The following two pages show part of Smith's Dock site with Baird and Barnsley's yard to the right, at the end of Duke Street.

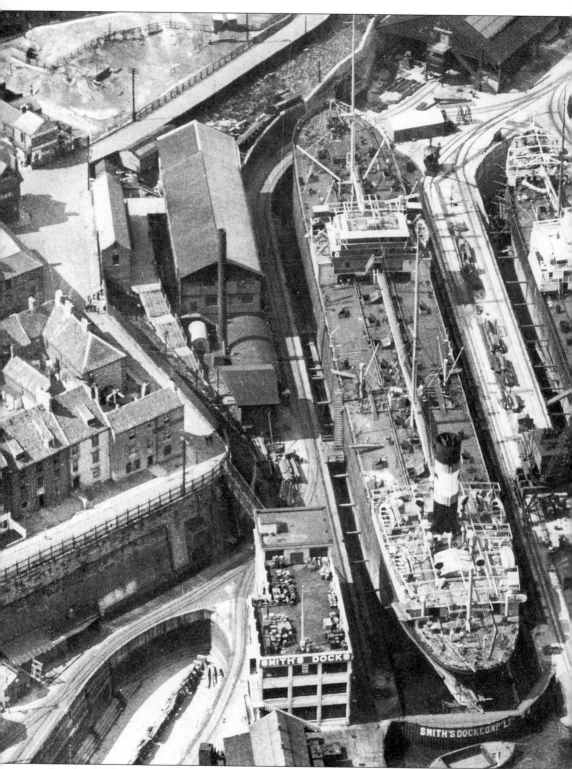

Smith's Dock, c. 1930.

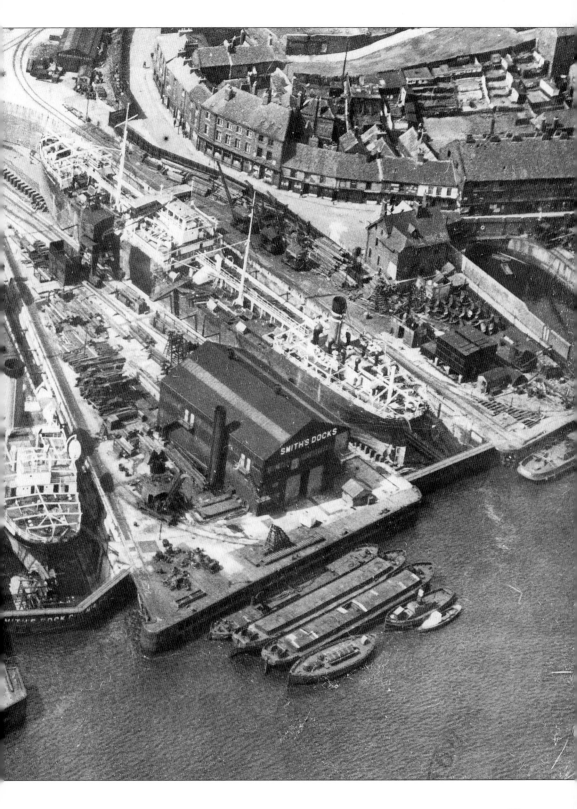

Haddock Shop, c. 1910. Young's graving dock was taken over in 1904 by Richard Irvin's Shields Engineering. They catered to the fishing fleet and the North Sea lightships. With the development of the Dolphin Quays it became a basin for leisure craft.

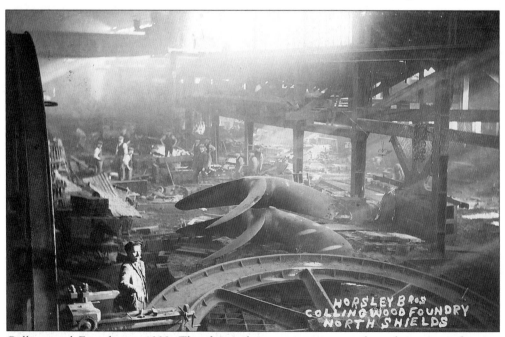

Collingwood Foundry, c. 1900. The shipyards gave rise to a number of support industries. Horsley Bros had their works on the corner of Coronation Street, opposite Smith's Dock.

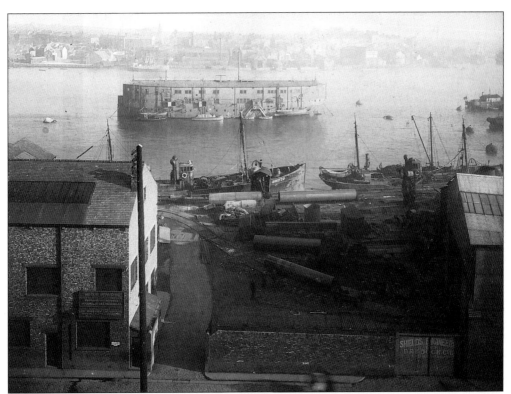

H.M.S. *Satellite*, 4 April 1928. Seen from Harbour View, the strange vessel is an ex-warship with a corrugated iron superstructure. She was the Royal Naval Volunteer Reserve training ship at North Shields from 1902-1936. She then moved to South Shields, and was there until 1947.

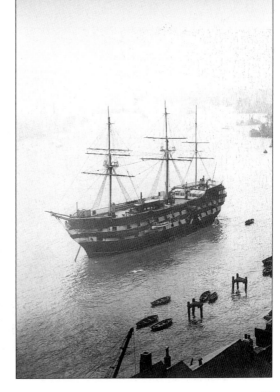

Wellesley, 1907. Previously H.M.S. *Boscawen*, she became the second *Wellesley* in 1873. As an industrial school she provided berths for 300 boys. (See also p. 57).

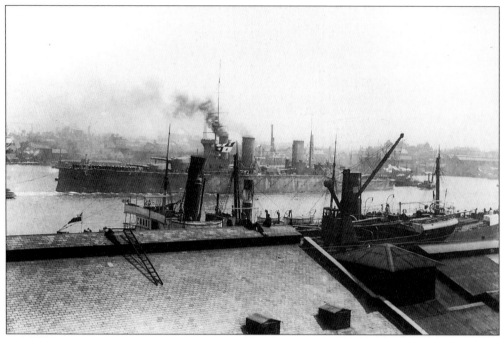

H.M.S. *Queen Mary*, 1913. Built at Palmers of Jarrow, this is one of many naval vessels the town has seen on their way into history. The battlecruiser *Queen Mary* was sunk at the Battle of Jutland on 31 May 1916.

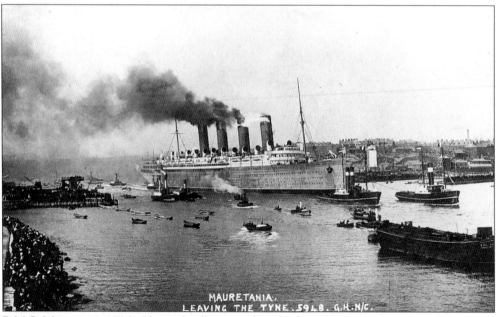

R.M.S. *Mauretania*, 1906. Always fondly remembered, when she was built at Swan, Hunter & Wigham Richardson's Wallsend yard she was the largest liner ever launched. She held the Atlantic Blue Riband until 1929.

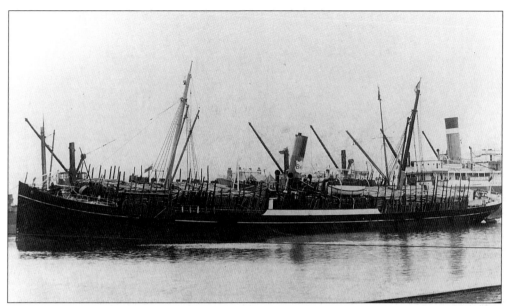

Waterville, c. 1908. Delivered in 1891, she was the first of the North Shields-based Balls & Stansfield Line. She seems to be carrying a typical cargo of Baltic timber. The ship was sold in 1915.

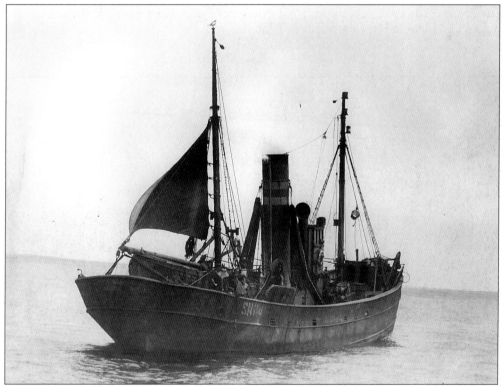

Ben Hope, c. 1954. Richard Irvin, of North Shields, was one of the earliest developers of the local fishing industry. This ship, one of the 'Ben boats', sailed from North Shields between 1936 and 1940 and then was transferred to the company's Aberdeen base. She was scrapped in 1955.

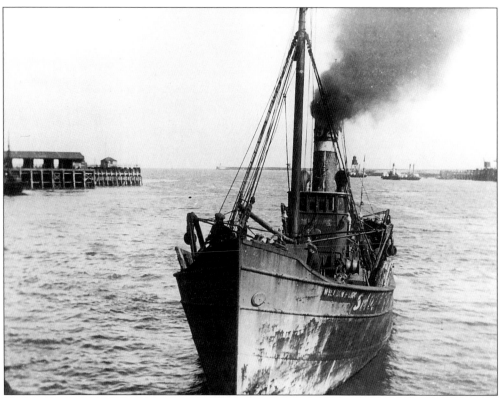

William Purdy, c. 1930. Having begun steam-powered fishing on the Tyne, Mr Purdy built up his own fleet. Purdy Trawlers sold their last boat in 1967, to manage the Ranger factory ships. They closed when P&O sold out in 1974.

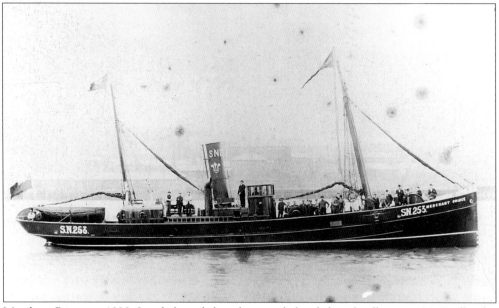

Merchant Prince, c. 1890. It is believed that the man behind the wheelhouse is Mr Fyall, who commanded the *Messenger* on the first steam trawling voyage from the Tyne. (See also p. 16).

Three

The Low Street

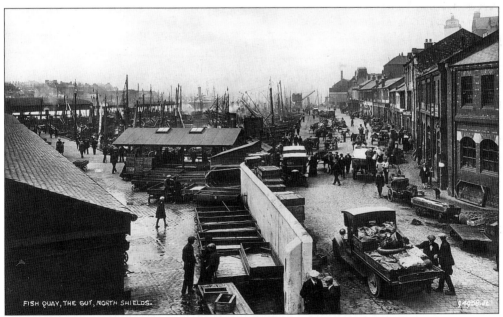

FISH QUAY, THE GUT, NORTH SHIELDS.

Union Quay, c. 1920. A fishing boat packed Gut is the reason for all the activity in the Low Street outside the market wall. In the distance is the smokestack of the ice factory built by the Council in 1895.

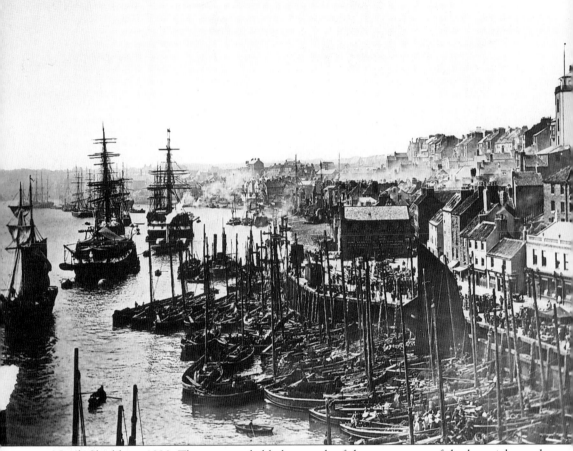

North Shields, c. 1890. The town probably has much of the appearance of the late eighteenth century, with many of the population crowded onto the bankside. In the foreground, the Protection Jetty has not yet enclosed the Gut. Union Quay was built in stages through the 1870s, but did not have its modern line until 1922. To the right are three of the legendary one hundred pubs along the Low Street. The balustraded roof marks the Old Highlander, with the Lord Collingwood and Newcastle Arms beyond. The latter were on the site of the Royal National Mission to Deep Sea Fishermen. At the end of Union Quay the dark building was Ralph Pigg's sail loft and ship chandlery. The original main road through North Shields narrows here, at the beginning of Bell Street. Behind the warehouse there are still mudflats at low tide, with gridirons to rest ships next to the engineering works and shipfitters. In the river are two old warships. The nearest is H.M.S. *Castor*, the Royal Naval Reserve training ship, on station from 1860-1895. The training ship *Wellesley* was moored astern between 1873-1914. She was formerly H.M.S. *Boscawen*. (See also pp. 27 & 57).

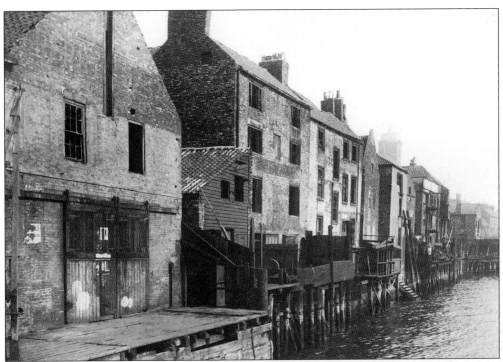

Bland Square Quay,
1914. With riverside
space at a premium
many workshops and
warehouses were built
on pilings. Some were
later tenemented. The
Bell Street section was
demolished in 1914 and
the people moved to
Balkwell.

Kirkcaldy Arms, c. 1899.
Bell Street was barely
wide enough for a cart
to pass along. Fifty years
earlier the pub had been
the North Star Inn.
From 1907 it was Crosby
Taws' butchers shop,
and later Wight's
grocery.

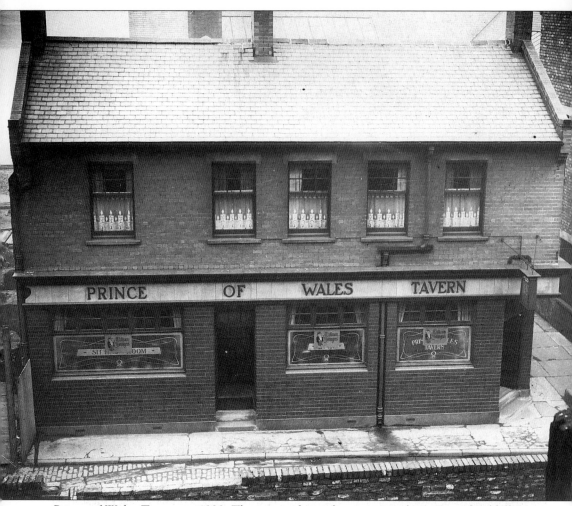

Prince of Wales Tavern, c. 1930. There is evidence for an inn at the corner of Liddell Street and Custom House Quay as early as the seventeenth century. This building, however, dates from 1927. Curiously, Custom House Quay was so named long before there was a custom house in the town. This site is the traditional home of the North Shields Wooden Dollies. Shipowner and brewer Alexander Bartleman is said to have erected the first, an old ship's figurehead, around 1814. It became the custom for sailors to cut off slivers for good luck, and the first figure was destroyed. Another was put up in 1820, by a Mr Hare. Yet another was set in place on 22 June 1864 in celebration of a proposed Low Lights Dock. That was broken in half in the mid 1890s, prompting a series of letters to the press, calling for a replacement. The fourth Dolly was carved by Miss May Spence for the Coronation of 1902. A copy was placed in Northumberland Square in 1958. When the Prince of Wales was saved from demolition in 1992, the brewers, Sam Smith of Tadcaster, returned a likeness of the third Dolly to the original site.

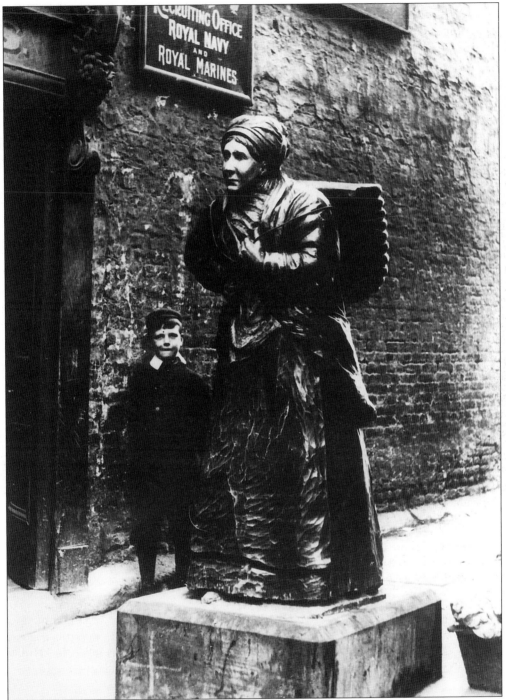

Wooden Dolly, c. 1902. Miss Spence's Dolly takes the form of an old fishwife, with her creel on her back.

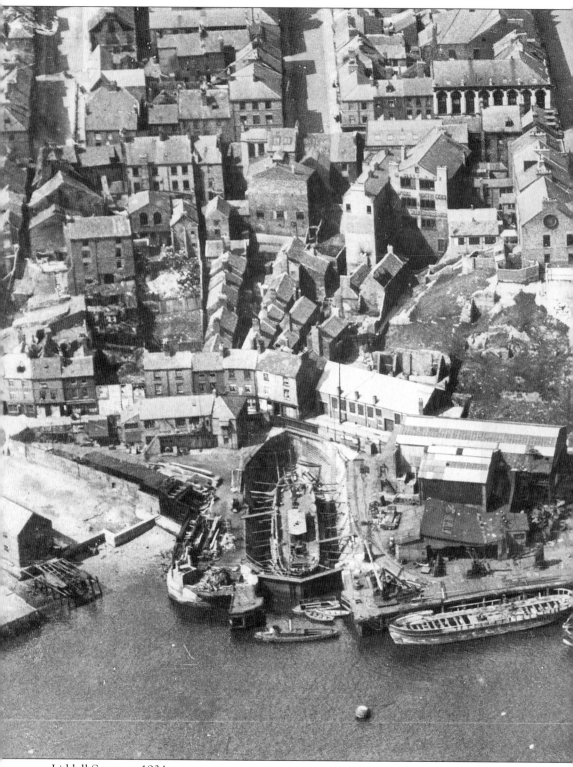

Liddell Street, c. 1934.

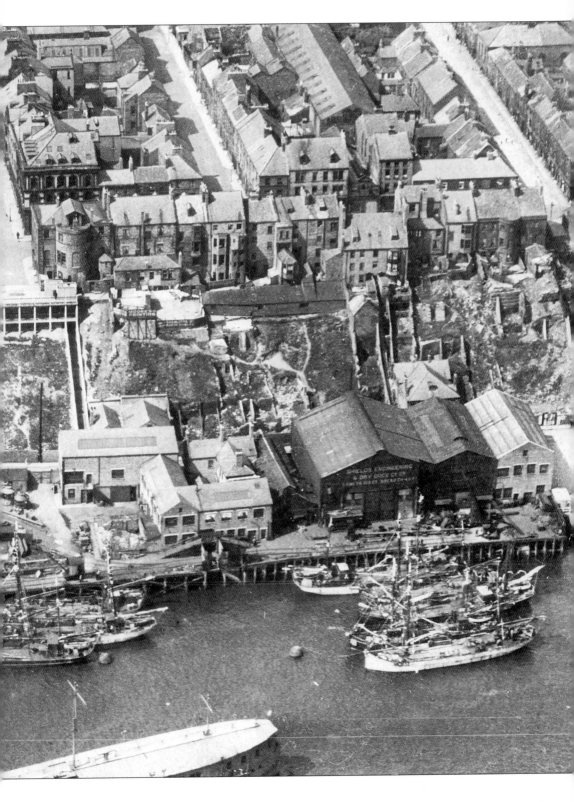

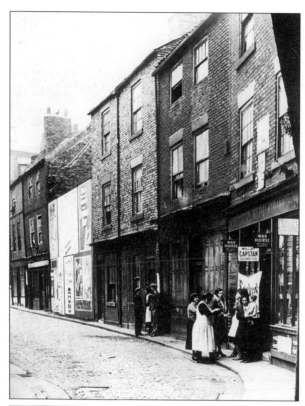

Liddell Street, 1933. Opposite the end of Young's Dock (see p. 36) was Pilgrim's shop. In the previous century it had been the Green Man public house.

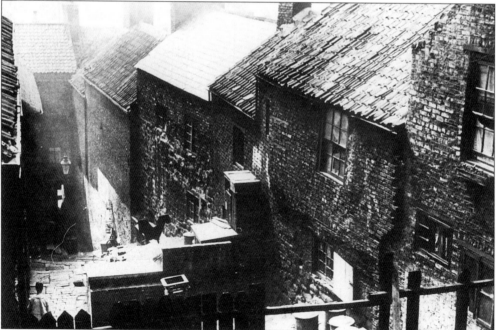

Greenman's Bank, 1933. The banks and stairs of early North Shields frequently took their names from the shops on the main road at the bottom. These properties lay behind the Green Man. Demolition had begun by the time of the photograph on p. 36.

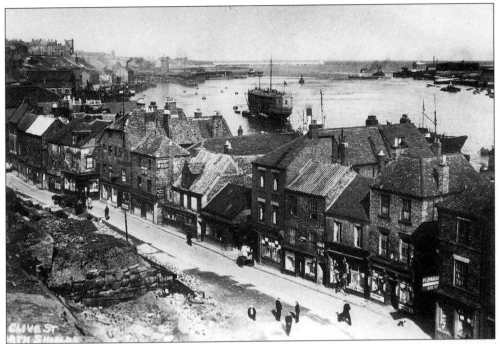

Clive Street, c. 1935. The bankside town was coming down from 1933, but the presence of H.M.S. *Satellite* puts the date before 1936. The white building is Cameron's shop.

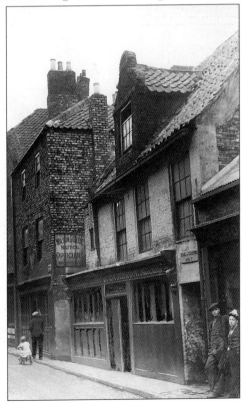

Star & Garter Inn, c. 1920. Before the turn of the century Cameron's rubber and asbestos store was a pub, said to date from Tudor times. Next door was the Lindsay Arms, taken over in 1913 by Wilson & Gillie, compass makers who later became Lilley & Gillie

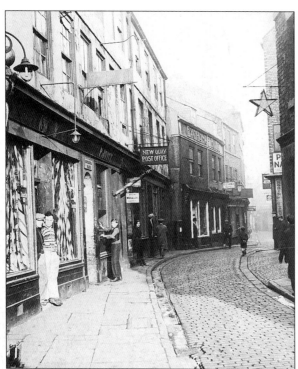

Clive Street, c. 1930. C.D. Merkel, jeweller and watchmaker, had his shop to the left, with a pawnshop up Britannia Bank. Previously the Waterloo, the Exchange Hotel opened around 1875, and continued until 1934.

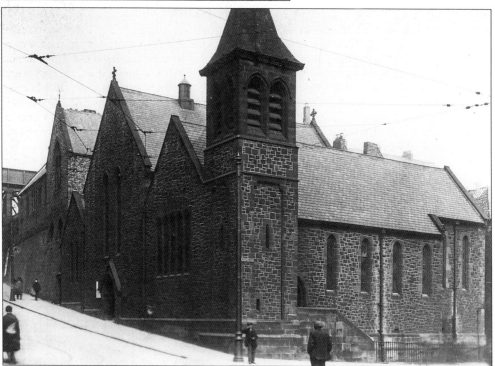

St Peter's church, c. 1930. When the old Parish of Tynemouth was divided in 1861, the Duke of Northumberland paid for the building of St Peter's, 'the Sailors' church'. It opened in 1864, closed in 1929 and came down in 1936.

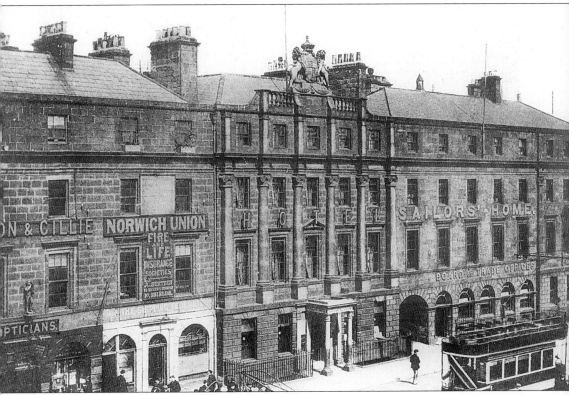

New Quay, c. 1910. The Duke of Northumberland built the first deep water quay in the town in 1806, intending that it serve as a market place, surrounded by imposing buildings. The market was not a success, allegedly because the fishwives refused to pay the tolls. Wooden shops were built, and a mountebank's stage erected, where, among others, the touring acrobat, Billy Purvis, used to perform. The Northumberland Arms, sometimes known as the Duke's town house, was completed in 1808. From its porch the April and November fairs were declared. For over a century it was a first class hotel, although latterly it was notorious amongst sailors the world over as 'The Jungle'. To the left is the original home of Wilson & Gillie (see also p. 39). The corner site held wooden shops until 1851, when the Duke had it cleared to build the Sailor's Home, in response to a public subscription which raised £3,000. It provided cheap lodgings until 1938.

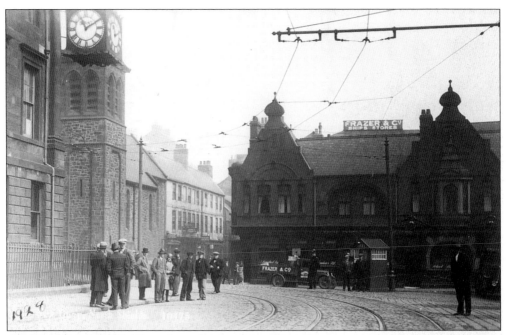

Golden Fleece, c. 1930. The pub on the east side of New Quay was some sixty years old when it was rebuilt around 1897. It is said to have been the first in the town to use the long bar and glassware, perhaps in the 1860s.

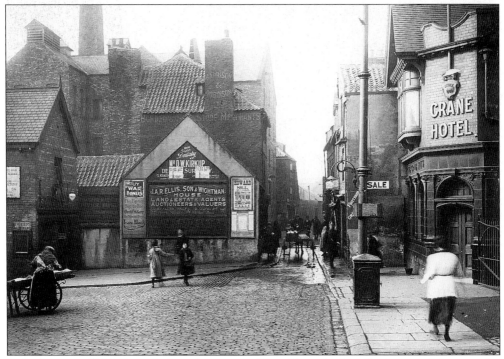

Duke Street, c. 1920. From the broad expanse of New Quay the Low Street passed down to the Bull Ring. The Crane Hotel, Crane House earlier, stood at the entrance from the 1830s, although the tiled frontage dates from 1905.

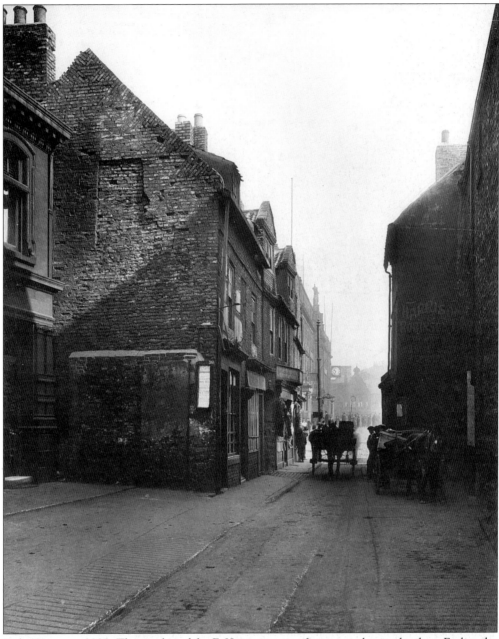

Duke Street, c. 1920. The signboard for F. Kristensen, outfitter, is a clue to the date. Earlier the premises had been E.A. Nyborg's dining rooms.

Chapel Stairs, 1933. In 1759 the house in the centre became James Rae's chapel. The congregation left in 1811 to enter the Scotch Church. They were followed by the founders of St Columba's Church in Northumberland Square, and in the 1840s by the Seamen's Bethel.

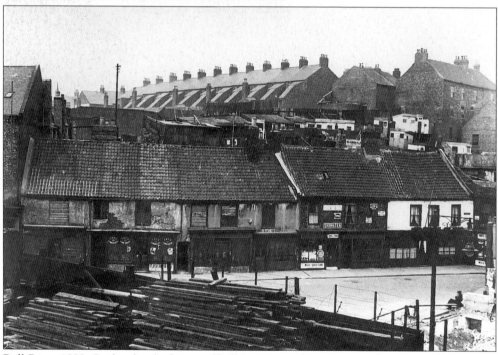

Bull Ring, 1933. Said to be the home of bull-baiting in the seventeenth century, this was the end of the Low Street, and the nineteenth-century coach terminus. Chapel Stairs are above, to the right.

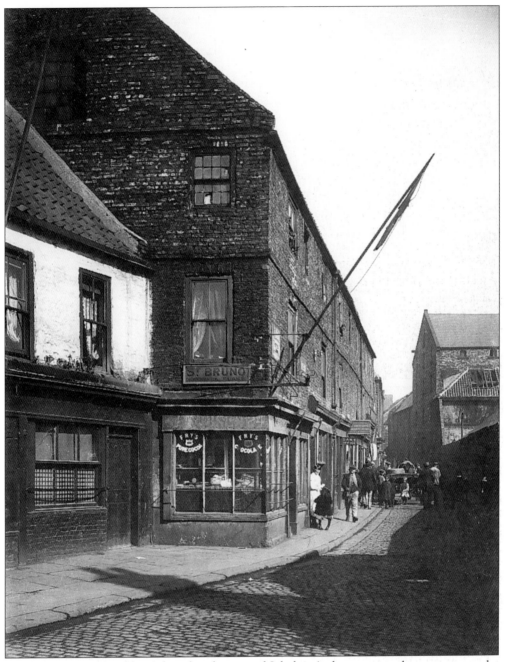

Duke Street, c. 1920. Olsen's boarding house and Jakobsen's shop were at the entrance to the Bull Ring.

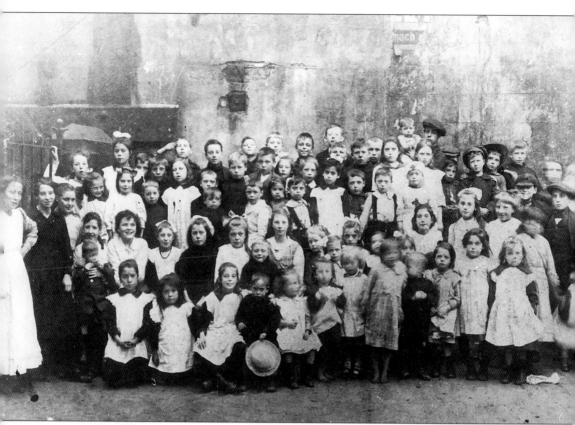

Victory Tea, 6 September 1919. August and September saw a spate of street parties, to celebrate the end of the First World War. These are the Bull Ring children. At the left, in a white pinafore, is Mrs Amess, wife of Joe Amess, the pigeon seller. Standing third from the left is Jenny, their daughter. The small boy pulling a face is held by Adelaide Cameron. Flo Anderson, whose father, Charlie Anderson ran the newsagents, is hanging on the railings. Winnie Low has a large white bow; she played the piano at the Tyne Cinema. Her sisters Louie and Margaret are at the left side of the bottom row. Their father Ching Low, ran a Chinese boarding house. The smiling girl next to them is Annie Currie who later became a nun. She is kneeling in front of Agnes Olsen, from the seamen's boarding house. Next to her in a plaid smock, is Tissy Nobbs, who became Mrs Elizabeth Bell. At the back, in front of the saluting boy, is Florrie Miller, who married the boy third to her left, Jimmy Olsen. Fair-haired Sam Twelves is behind him.

Four
School Days

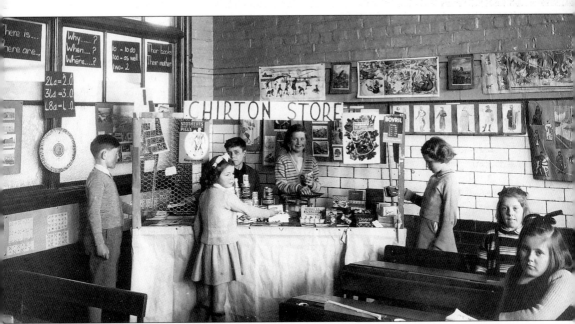

Chirton Junior Mixed School, 1950. Standard 2B are using the play shop as a means of learning mental arithmetic. They are in their temporary home at Queen Victoria School as Chirton was bombed in the Second World War.

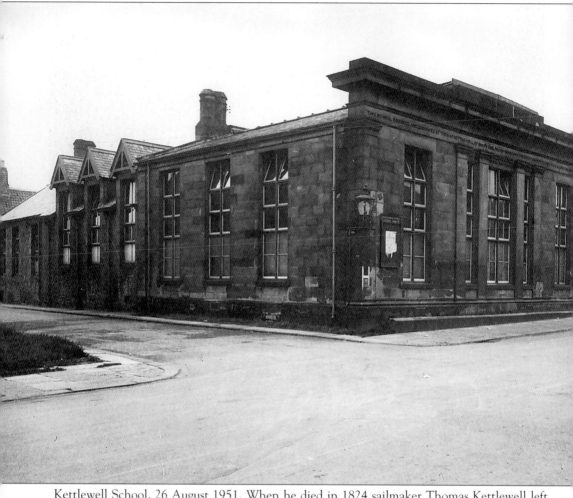

Kettlewell School, 26 August 1951. When he died in 1824 sailmaker Thomas Kettlewell left land at George Street, and an endowment to found a school for the poor children of North Shields. It opened in 1825 and soon took 200 boys. Between 1902 and the Second World War 12-14 year olds were taken. Post-war the building became the East End Boys Club which was demolished in 1964. This was not the only early attempt to provide schooling in the town. The Royal Jubilee School was begun in 1810, using the liberal Lancasterian system, following lobbying by the Quaker community. Under the headmastership of Thomas Haswell, 'The Maister', 1839-1886, it became renowned in the area for the breadth of its education. There was actually a drop in standards when State education was instituted. The Church of England had National Schools at Christ Church and Holy Trinity. The Roman Catholics, and the Scotch Church had their own schools, and clergymen usually organised the Ragged Schools. Private education was also available. The Revd William Lietch, for instance, founded the Albion Road Academy in 1812. His successors Messrs Ryder and Manson kept it up into the 1920s. With the Education Act of 1870 schooling became compulsory, and Tynemouth set up an elected School Board. Until education became a local authority responsibility in 1902, the Board built schools and oversaw teaching in the Borough.

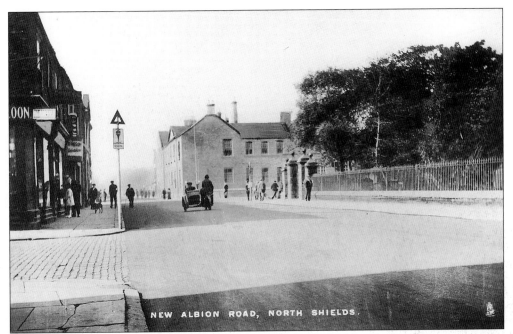

NEW ALBION ROAD, NORTH SHIELDS.

Royal Jubilee School, c. 1930. Opening in 1811, the large school enjoyed a high reputation for over a century. After closing in 1935, the building continued in use until 1971. A commemorative garden opened on the site in 1989.

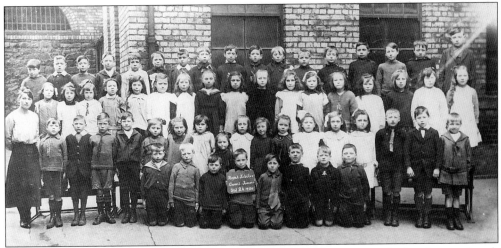

Royal Jubilee School, Standard 2B, 1920. Standing in the front row is Arthur Larsen, fourth from the left with Stan Kennedy, 15th. Kneeling down are T.A. Stoddart, first on the left with Jimmy Hill third.

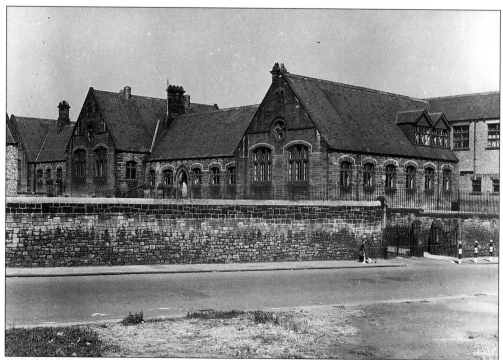

Western Board School, 1949. One of the first of two schools built by the Tynemouth School Board, Western opened its doors on 2 June 1874. It survived just over a century.

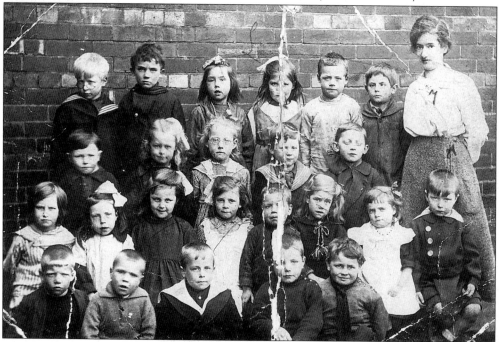

Western Board School, 1919. Left to right in the top row are: 2nd, R. Bell; 3rd Wells; 5th, T. Denton; 6th, J. Beck. Second row: 1st, Scofield; 3rd, M. Lambe. Third row: 1st, J. Hall. Front, 1st, 2nd and 3rd, G. Fairley, Johnson, and R. Jameson.

Eastern Board School, 1969. By this time the school had been closed some thirty years. It opened in East Percy Street on 13 June 1876, taking over part of the role of the Kettlewell School. It was requisitioned in the Second World War and afterwards sold to Tyne Brand Products.

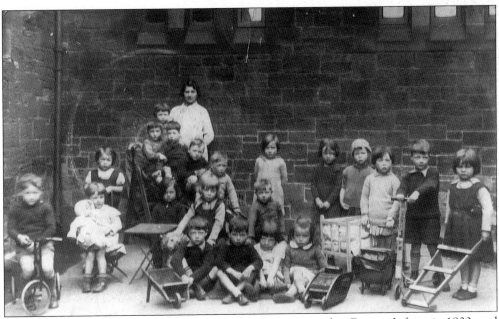

Eastern Board School, c. 1935. Miss D.E. Dobie was appointed to Eastern Infants in 1933, and transferred to the Ridges Infants in 1937. Philip Smith is sitting on the tricycle.

St Cuthbert's School, 1946. The school opened on Nelson Street, left, in September 1840. To the right is the convent of the Sisters of Mercy, opened in 1868. They amalgamated with St Joseph's, Lovaine Place, in 1958.

Union British School, c. 1960. Built by the British & Foreign School Society in Norfolk Street, it opened in 1840. Between 1906 and 1959 the building served as a fire station, hence the Bell & Bucket pub, opened in 1986.

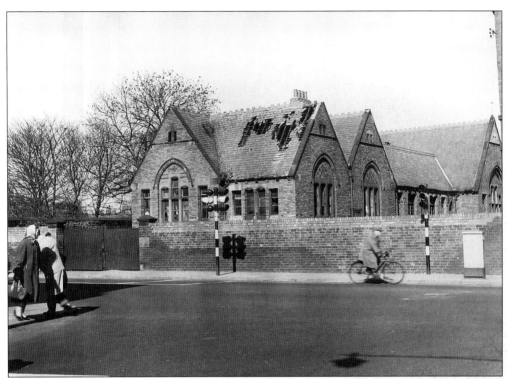

Christ Church School, April 1959. Headmaster William Urpeth admitted the first pupils on 6 May 1872. It was left vacant after the Second World War and the building decayed. It was demolished in 1963. The new Christ Church School opened in May 1965.

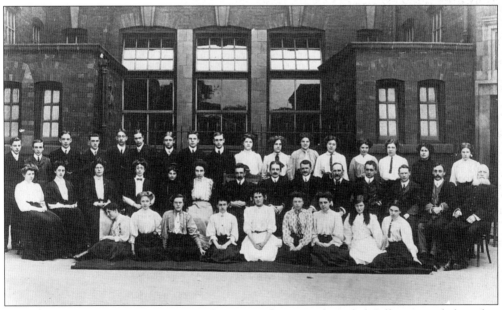

Pupil Teachers' Centre, c. 1907. Since this postcard was sent by Isabel Gillespy, it is believed to include the group which she joined in 1906, to begin training as a teacher. She was attached to Christ Church School until 1909.

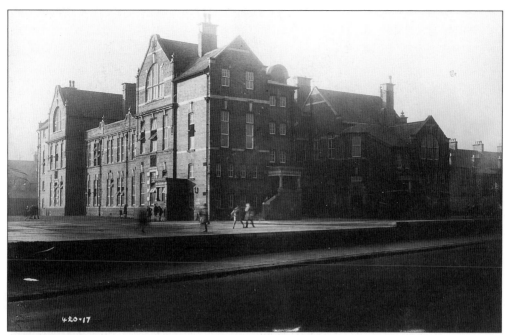

Queen Victoria School, 1946. Built on Coach Lane in 1898 as a mixed school, an extension in 1904 provided secondary education and a pupil teachers' centre. After 1981 it became the Queen Victoria Training Centre.

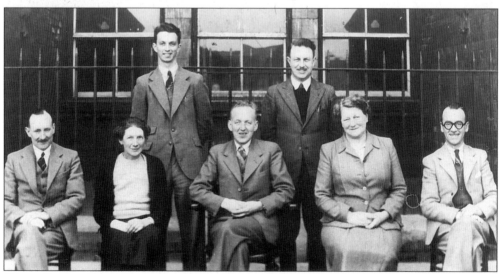

Queen Victoria School, c. 1950. The staff were, left to right: T. Lumley, Daisy Cairns, J.F. Gay, George Ainley (Head of Junior Boys), Derek Dickinson, Mrs Miller, and Jim Mountain.

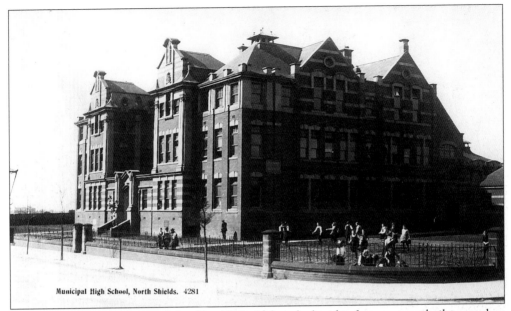

Municipal High School, North Shields. 4281

Tynemouth Municipal High School, c. 1920. Although the idea for a purpose-built secondary school was proposed in 1894, the foundations were not laid until 1907, with an opening on 8 November 1909.

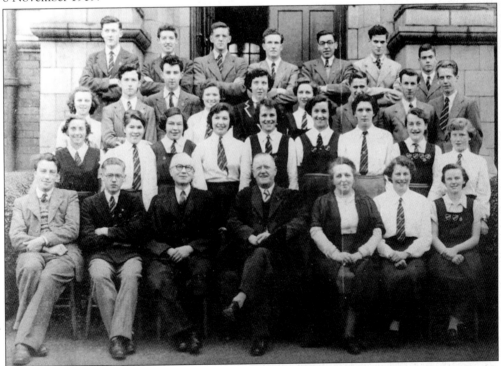

Prefects, 1951. In the row standing behind the High School staff are, left to right: Shirley Miller, Bridget Smith, Brenda Nattrass, Eleanor Westerback, Doris Jamieson, Jean Thompson, Helen Cheesmond, Brenda Boulby and Ann White. The Headmaster, seated centre, was J.H. Smedley.

Linskill Girls' School, 1949. Either side of the Headmistress, in the centre, Miss Jessie Patterson, are Miss Holmes and Ella Younger. Behind them, in the middle row are, left to right: Mrs Proctor, Mary Purdie, Elsie Bell, -?-, Margaret Pratt, Miss Pilmer, Gladys Bainbridge, Bessie Hill, Miss Page, Marjorie Patterson and Ruby Larson.

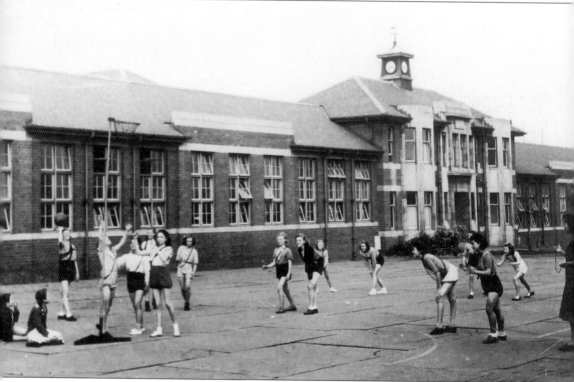

Linskill Senior School, October 1949. Opened on 21 September 1932, Linskill provided separate blocks for boys and girls. The creation of the John Spence School in 1984 saw Linskill's gradual conversion to a community centre.

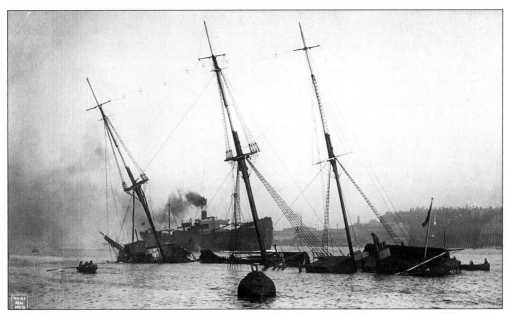

Wellesley Training Ship, 1914. Neglected boys, or those keeping bad company, could be sent to train for a life at sea. Ex-H.M.S. *Boscawen* was the second *Wellesley* on the Tyne, serving between 1873 and 11 March 1914 when a fire sank her.

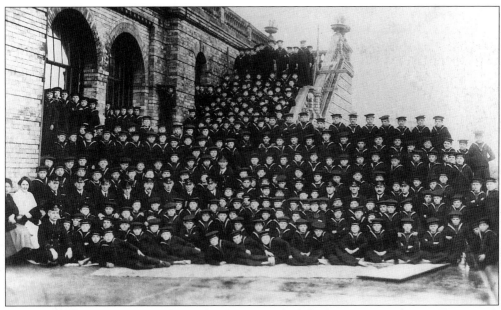

Wellesley boys, c. 1914. After their school was wrecked the boys went to live at Tynemouth Plaza, before moving to a shore station at Blyth in the 1920s.

Ralph Gardner Secondary School, 1949. Practising for the Tynemouth centenary are, left to right, Jean Jackson, Nancy Brown, Sheila Robinson, Hilda Stephenson, Ella Croft, Isabella Reed, Iris Chatton, Maud Fullen and Grace Gott.

Linton House School, 18 September 1869. Jane and Catherine Ogilvie moved their ladies' seminary to Preston Road around 1857. It closed around 1876.

Five
West End

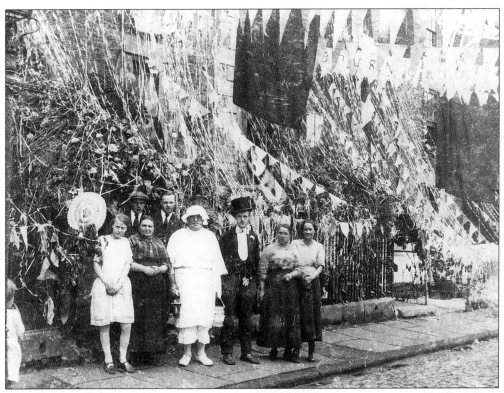

Front Street, c. 1926. Left to right, Mrs Keady, Mrs Thomasina Cunningham, J. Webster, Harry
Rutherford, as the Glaxo Baby, John and George Rutherford, Mrs Rutherford and Mrs Rogers
display their carnival spirit.

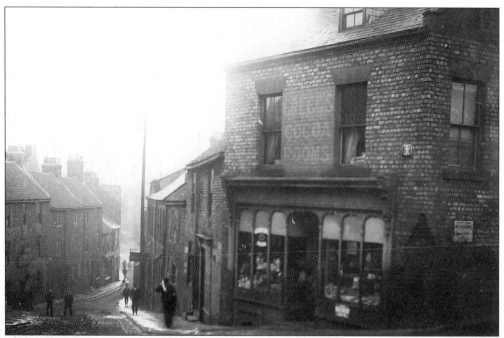

Dotwick Street, c. 1900. Named after the Durtwick Sand, long since dredged, this street connected the Bull Ring to Milburn Place. Sir Harry Gregg had a chain of temperance cafes in the area. The Smith's Dock Company demolished the street.

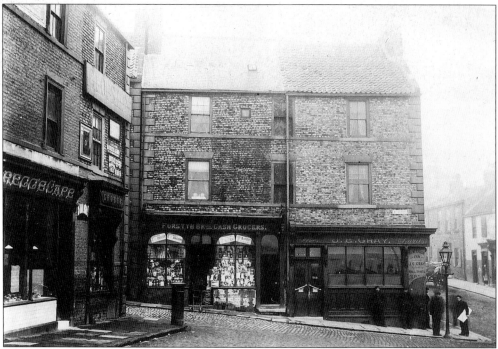

North Street, c. 1905. The New Dock Inn on the corner probably commemorates the opening of Smith's Dock in 1852. When rebuilt around 1920, it took in Forsyth Bros' shop. To the far right is the Wagon Inn, New Row.

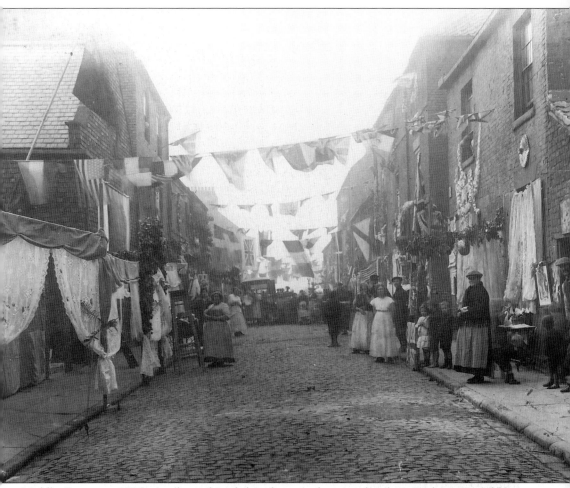

Middle Street, c. 1925. At the right of the photograph, in a shawl, is Becky McLaughlin. Milburn Place was widely known for the enthusiasm with which it entered the carnival season between the Wars. The streets were decorated with flags, coloured paper, shrubbery and even the lace curtains from the windows. Middle Street lay between South, or Front Street, and North Street, which, with East and West Street, constituted Milburn Place. The land had been owned by the Milbournes of Chirton House, but descended through marriage to Edward Collingwood, who developed the area in the 1780s. This was one of the earliest expansions of North Shields out of the smoke and grime of the Low Street. The larger houses were built on the edge of the cliff above Limekiln Shore, and had commanding views over the harbour, and towards the south. It is recorded that many of the original residents objected to the ballast hill begun on the south side by Smith's Dock in 1822. The flint and chalk offloaded by collier brigs grew to dominate the houses, and people moved out. Respectable though they had been, by the standards of the day, as many of the houses became overcrowded with poorer tenants, health problems arose. By 1936 the Council had begun demolition, and the community was moved to the Ridges Estate. Most of the land was sold to Smith's Dock for storage.

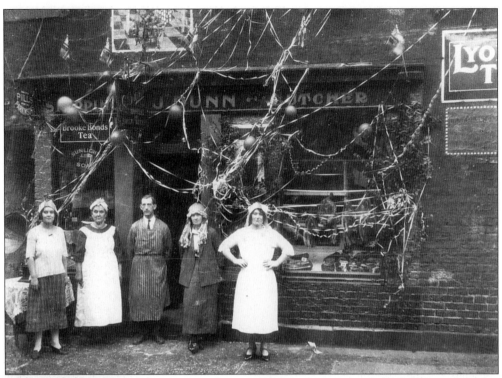

J. Dunn, c. 1925. Mr Dunn had No. 27 Middle Street by 1924, and held it until 1936. He followed his customers west, with a shop at Marina Avenue. Here are Miss and Mrs Bell, James Dunn, and in white, Mrs Dunn.

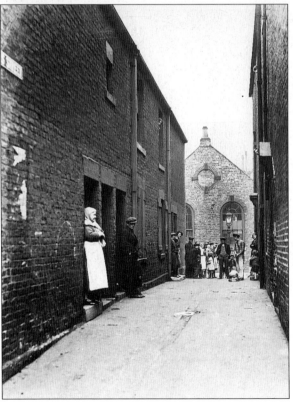

Cross Street, 1933. In the background is the Sunday School on Middle Street. It lay behind the Methodist church on Front Street, built in 1786 where the Wesleys preached in the open air several times.

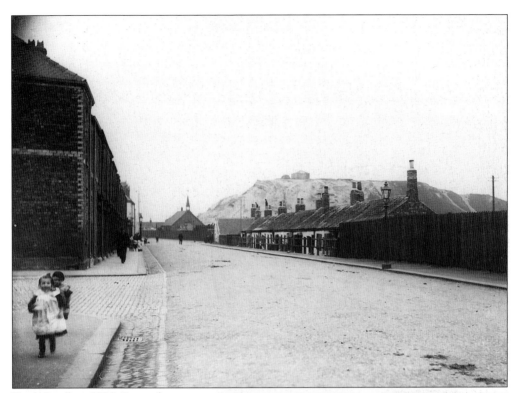

Dock Road, c. 1900. Beyond Robson's Row cottages are the Ballast Hill and Holy Trinity's mission chapel. The Tyne Commission started to remove the ballast in 1905.

The One O'clock Gun, c. 1900. The British Association for the Advancement of Science first fired the time gun on the top of the Ballast Hill on 18 August 1863, by telegraph from the Royal Observatory, Edinburgh. It was last used on 31 August 1905.

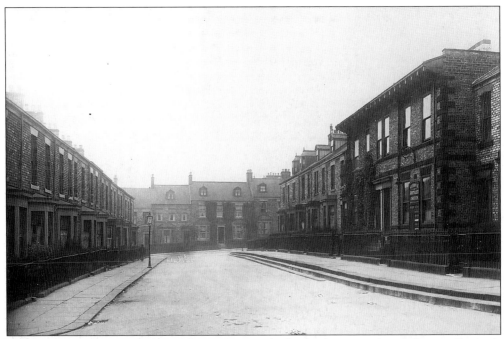

Stanley Street West, c. 1930. The street was built in the grounds of George Rippon's Waterville, seen to the right in its later guise as the Spiritualist church. It was a John Dobson building and survived until it was bombed on 30 September 1941.

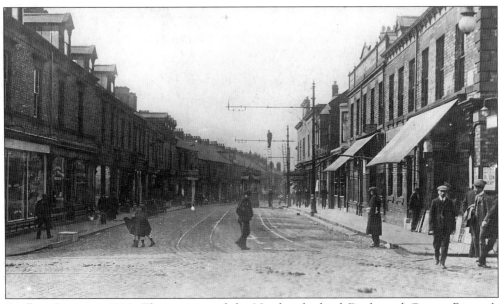

Prudhoe Street, c. 1920. The opening of the Northumberland Dock, and George Rippon's entrepreneurial spirit, led the town to develop westwards in the 1860s, from Saville Street, through Prudhoe Street, to Howdon Road.

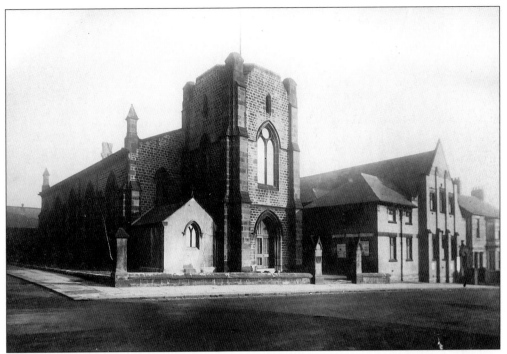

Holy Trinity church, 1946. When Tynemouth divided in 1861, the new Parish of Western Town was centred on the Holy Trinity Chapel of Ease, which had opened on Coach Lane in 1836.

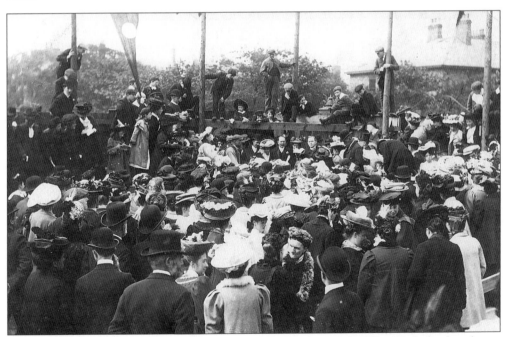

Wesley church, 1907. One of a series of Methodist churches at the West End, the foundation stone of the Wesley Church was laid on Coach Lane on 19 June 1907. It was destroyed by a fire bomb in 1941.

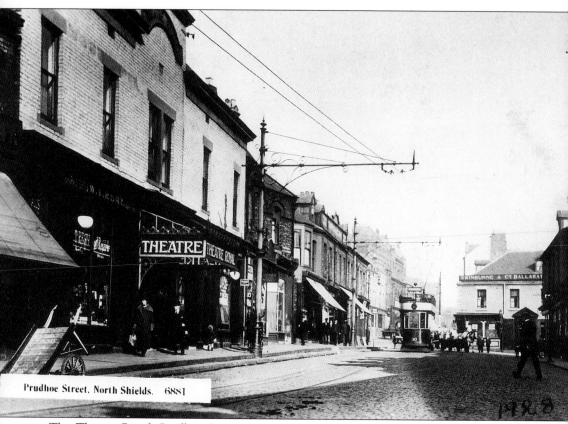

Prudhoe Street, North Shields. 6881

The Theatre Royal, Prudhoe Street, c. 1925. Opened on 22 December 1879 as the Grand Theatre of Varieties, it became the Theatre Royal within a few weeks. S.R. Chisholm was the owner, and when he retired in 1895 he leased the building to Arthur Jefferson. The new manager was very active, running in addition theatres in North Shields, Wallsend, Hebburn and Blyth. His popularity in the town gave him a seat on Tynemouth Council. It is said that his son Stanley first went on stage here on Mafeking Night - he is better remembered as Stan Laurel. The theatre was sold in 1932, but an expected conversion to a cinema was not carried through, and the building came down in 1939. In the background is one of the green trams of the Tyneside Tramways & Tramroads Company, which came from Gosforth Park via Wallsend. They were unable to pass through into Saville Street West because the blue cars of the Tynemouth & District Electric Traction Company used a narrower gauge. Tyneside Tramways ran between 1902 and 1930. The Ballarat Hotel is beyond the tram, at the corner of Borough Road and Saville Street West.

66

Six
Sport and Leisure

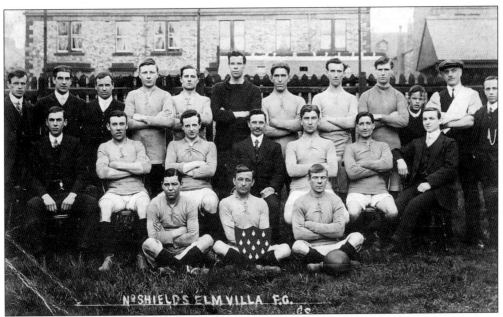

Elm Villa Football Club, c. 1912. One of the lost clubs of North Shields, Elm Villa is known to have played before the First World War. In 1912 they amalgamated with the Caledonian Football Club.

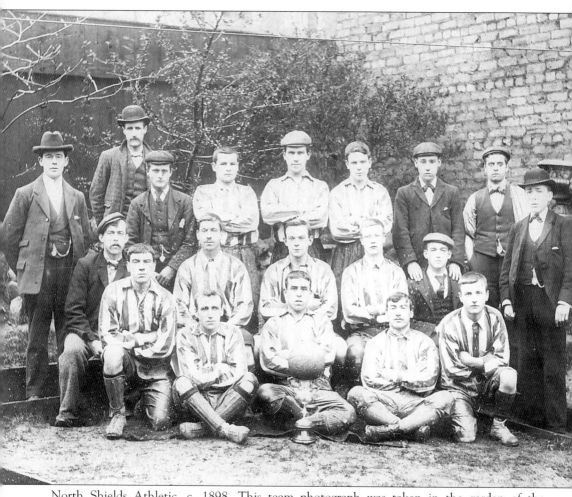

North Shields Athletic, c. 1898. This team photograph was taken in the garden of the Woolsington Hotel, presumably because it was close to the Dock Road ground. At the time they were nicknamed 'The Dockers', although they had descended from the Preston Colliery club. Back row, left to right: Mr Taylor, president, -?-, Bob Newton, Scottie Harburn, Martin Spendrift, Jack Brown, Jack Reed, R. Smith, trainer, Sep. Browell, secretary. Centre: J. Simpson, R. McVay, J. Lamb, Barney Sylph, J. Hayes. Front: S. Currie, ? Brownlie, J. Borthwick, W. Currie, Nelson Gray. The team played in red and white. Following their win in the Northern Alliance, Athletic became a limited company in 1907. By that time they had moved to a ground in Hawkeys Lane. There seems to have been a gradual decline in the club's fortunes, which cannot have been helped when their grandstand burned down in 1917. In 1928 North Shields A.F.C. was founded just before the opening of the season. The first match saw them beat Seaham Harbour 4-1, heralding a rise to the top of the Second Division in the North Eastern League. They started the next season in the First Division. In a chequered career, possibly 'The Robins' proudest moment was at Wembley on 12 April 1969, when they won the Football Association Amateur Cup.

Appleby Park, 1931. The football ground on Hawkeys Lane was named in honour of fish merchant Joseph Appleby, an active campaigner for North Shields A.F.C.

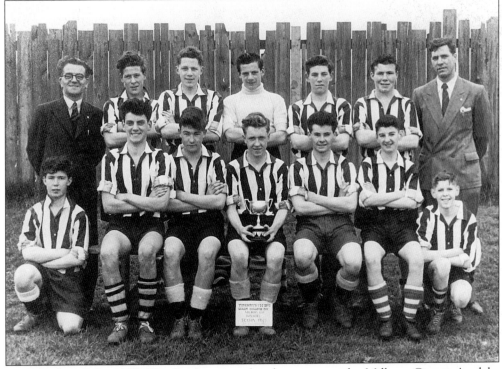

St Columba's F.C., 1955. The Presbyterian church team won the Milburn Cup at Appleby Park. Back row: Tommy Lillicoe, Jimmy Dack, Jacky Oliver, Dave Percy, Ken Sutton, Colin Clark, Bert Howard. Front: Ken Mordue, Martin Murray, Gordon Stark, Don Graham, Ken Allen, David Drew, John Rivett.

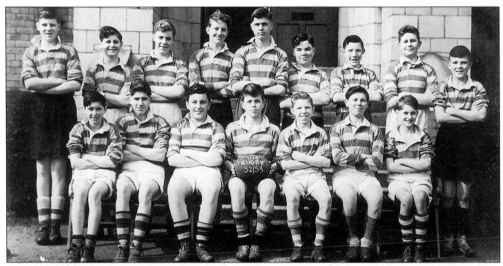

Tynemouth High School, Under-14 rugby team, 1953. Back row, left to right: Colin Snowdon, John Cooper, Frank Mavin, Arthur McKenzie, Neville Ferguson, Derek Hull, Edward Atkinson, David Harris, John Potts. Front: Albert Snowdon, Cyril Innes, Joe Stephens, David Oxnard, Ralph Butler, Ken Sutton, Geoff Renner.

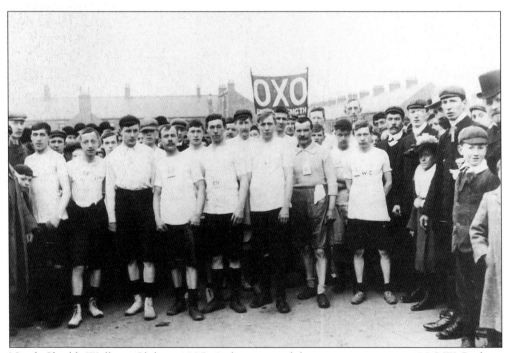

North Shields Walking Club, c. 1905. At least one of these men is wearing a N.S.W.C. shirt. The club was founded around 1902 and they were still racing in 1908.

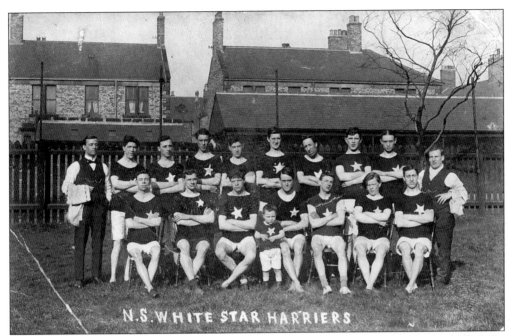

White Star Harriers, c. 1912. The runners seem to have shared a ground with Elm Villa F.C., although they met at the Neville Hotel. Standing sixth from the left is George A. Eggleston, the club auditor.

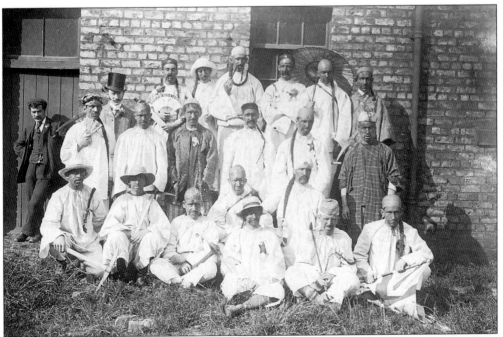

Collingwood Wesleyan Cycle Club, June 1904. Members of the Collingwood Street chapel are making a topical political joke. The man in the top hat represents Colonial Secretary Joseph Chamberlain, who wanted to transport 24,000 Chinese labourers to South Africa.

Barney Meet, c. 1925. At Whit weekend cycling clubs from all over the North used to meet at Barnard Castle. North Shields' Tyne C.C. have taken over Mrs Golightly's cafe as their headquarters and adopted a Dutch theme.

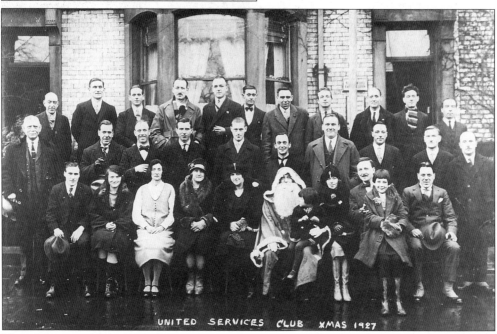

United Services Club, 1927. Sweets, toys and scarves were distributed to over 500 children at Lovaine Place on Christmas Day. Santa Claus was Thomas William Armstrong of the Hollies Concert Party. Between the windows is club steward Henry Garner.

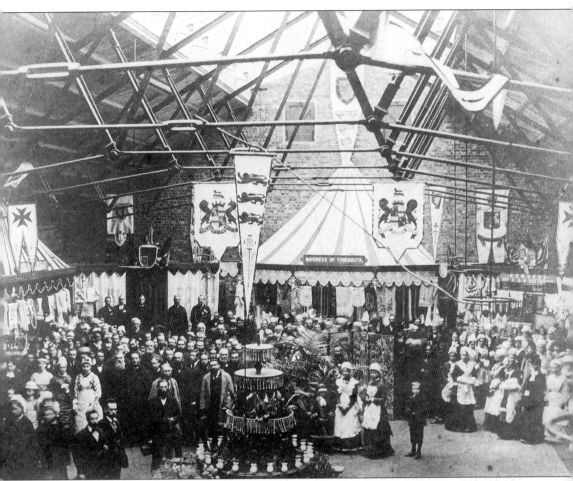

Drill Hall, 1878. Tynemouth Artillery Volunteers were both a proud military formation and an important social organisation. Enrolled in 1859 to meet a perceived threat from Napoleon III, it was the first volunteer artillery corps in the Kingdom. An attempt to remove the precedence of the 1st Northumberland Artillery Volunteers, in 1886, met determined resistance. When the Drill Hall was opened on Military Road, a bazaar was held to meet the costs. Mr Brown, of Tynemouth Aquarium, turned up to take the photograph. To the left, stall C was in the charge of Mrs Henry Bell and the Ladies of Tynemouth. The Mrs Dawsons and Miss Simpson ran 3 & 4 Batteries' stand, to the right. In the foreground is Carnegie & Gullachsen's celebrated illuminated fountain. As was usual on such occasions, the town was scoured for exhibits to draw the crowds, including a local favourite, an ear cut from the executed 'Resurrectionist' William Burke. The Volunteers were absorbed into the Royal Garrison Artillery (Territorial Army) in 1908.

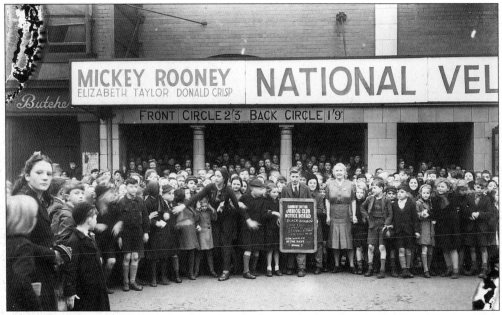

Gaumont Cinema, 1946. The Gaumont British chain introduced a branch of their Juniors Club to the Princes Theatre. The club promoted films and also arranged competitions and charity events. (See also p. 88).

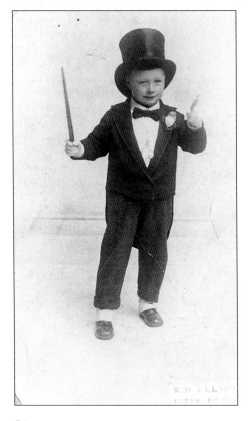

Roland Young, 1926. Although never a member, young Roland, aged three and a half, was the mascot of the Milburn Toffs jazz band, and the model for their banner.

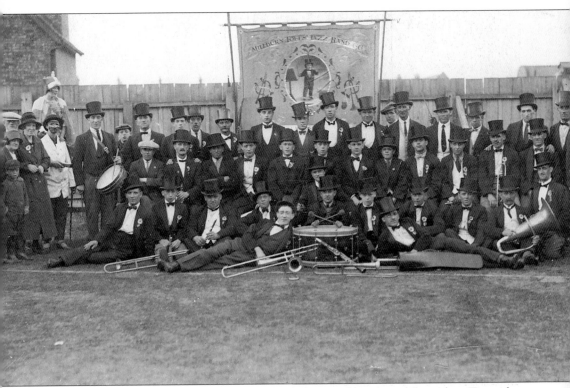

Milburn Toffs, c. 1930. Between the Wars 'jazz' or 'submarine' bands proliferated on Tyneside. With the simplest of instruments, the kazoo, and home-made costumes, people entertained themselves and collected for charities through the Depression years. One of the best remembered bands was the Milburn Toffs, from Milburn Place. They were brought together by Thomas Hunter and John Hudspeth for the Tynemouth Carnival of 1926, and survived until at least 1930. A junior branch was known as the Milburn Indians, from their feathered head-dresses. The Toffs supported local charities and organised treats for neighbourhood children. The clubroom was in East Street and band practice was held in a cycle shed at Smith's Dock. As with many West End festivities, the secretaries were supplied by the Rutherford family. The bands tended to be drawn from distinct areas of North Shields. The Dixie Coons and the Church Way Sports Club were from the town centre; the Rudolph Valentinos from the Low Street; the Tin Can Fusiliers and the Bobbed Hair Kids from the Low Lights; and the Colleens seem to have come from the East End. Another popular group was the Harold Lloyds, or Tennis Stars.

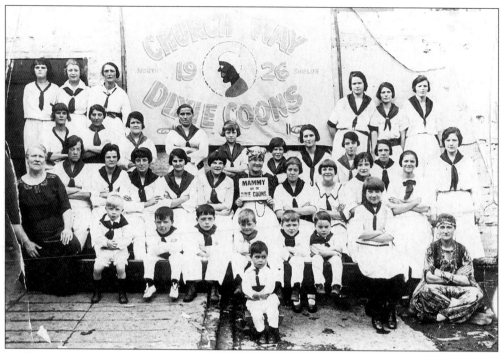

Dixie Coons, 1926. What would now be seen as politically incorrect (!), the men of Church Way marched in blackface. John Penman won the prize for best cornet player. Little Master Jasper is seated at the front.

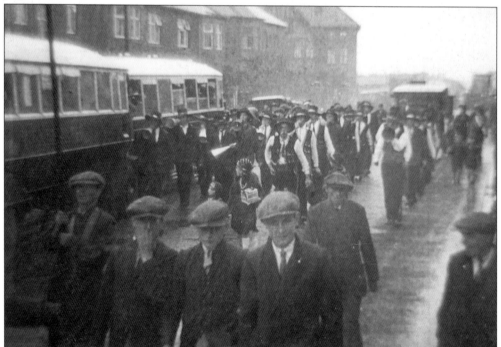

Rudolphs, 1930. A frame from a newsreel filmed by the Princes Theatre shows the Rudolph Valentinos following their banner to Tynemouth in the Carnival of August 1930.

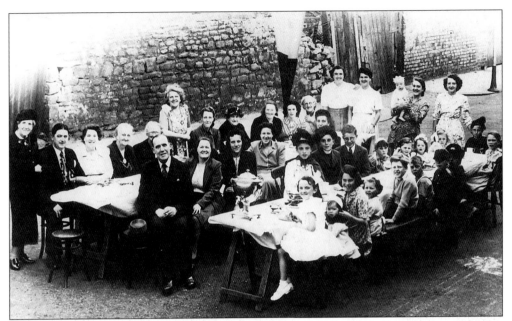

Little Bedford Street, c. 1950. A number of dates and sets of names have been presented for this picture. Some of the adults and many of the children are said to belong to the Marouli family. Mrs Berry of the Northumberland Arms is standing left.

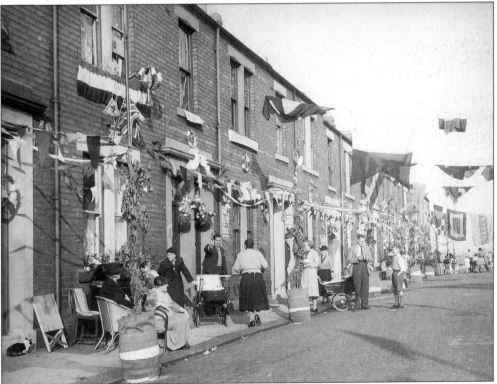

Waldo Street, 1953. Wilted foliage and the length of the shadows suggest that the Coronation Day festivities are drawing to a close.

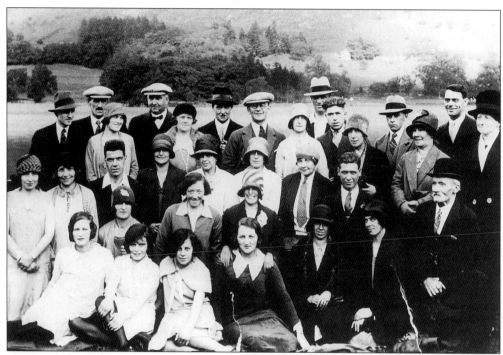

The staff of the Howard Hall cinema on a trip to the Lake District, 18 August 1929.

Northumberland Square, 1947. The Lakes were a popular venue for works outings. Members of the Council's outdoor staff include Stan Lyall, E. Richardson and A. Craig who are second, third and fourth from the left at the front. P. Heinz is far right. At the back, between two pale caps, is Vic Percy.

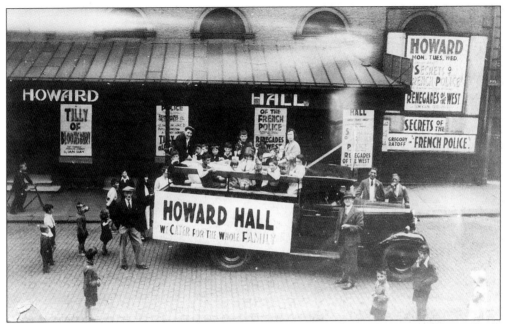

Howard Hall, c. 1933. A Wesleyan chapel from 1808, it opened as a theatre in 1891, and was converted for showing films in 1908. It was known as 'The Ranch' because of its regular diet of Westerns.

Hollies Concert Party, c. 1925. They were all amateurs and were directed by auctioneer and comedian T.W. Armstrong. Laura Armstrong was the pianist. Singers included Minnie Armstrong, Elsie Fenn, Lambert Guthrie, Geo. O. Newham, Henzell Robson, and Wee Peggy. Poppy Rowley was a male impersonator.

Joseph Maw, c. 1910. The Maws sold up in 1954 after a century as cab owners and undertakers. For forty-four years Joseph Maw had shown his Educated Ponies, and also had a troupe of performing dogs.

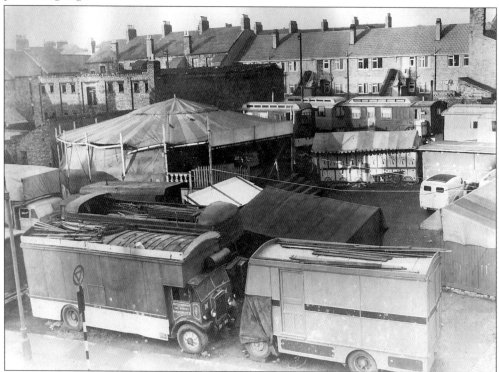

Murphy's Fair, 13 December 1956. Born into an established family of showmen, Walter Murphy made North Shields the base for his roundabouts. On this occasion the fair was pitched at Prudhoe Street, on the Theatre Royal site.

Seven

Town Centre

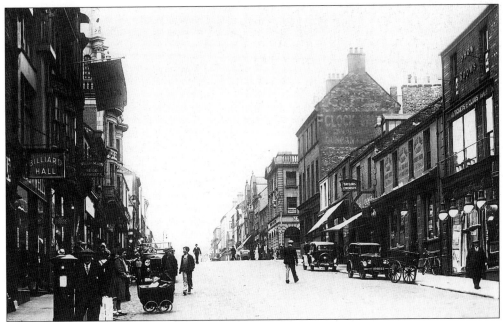

Bedford Street, c. 1930. This shows the diversity of the shopping centre, from Tweddell's drapery and Taylor the chemist, to the Clock Vaults, the Midland Bank and the Y.M.C.A. Beyond the Billiard Hall are Williamson & Hogg's and the Gas Office.

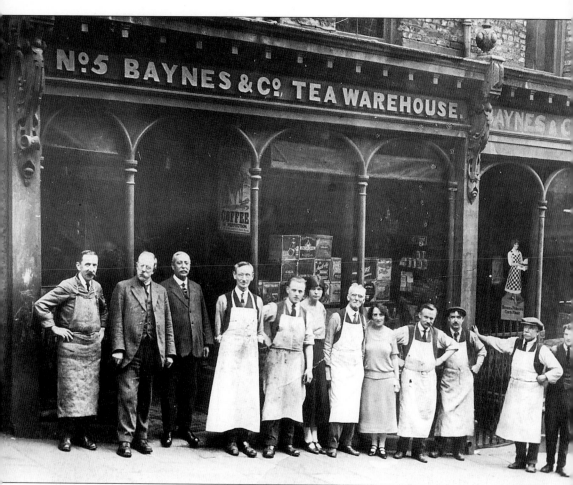

Baynes & Co., 8 September 1924. One of the old Quaker family businesses in the town, the shop was set up by Joseph Richardson. He sold it to his cousin, George Baynes in 1815. As grocers to the town and the shipping trade the firm prospered. Seen here at their height, the staff included, left to right: Jimmy Lyons, George Baynes, George Temple (head clerk), Jimmy Ridley (counter assistant), Billy Ward (assistant and cartman), Evelyn Mason (typist), Tom McCartney, Miss Wardropper, George Johnson (tea blender), Tommy Stoddart and Jimmy Cruikshanks (warehousemen), Mr Jessup. As the town was pulled down around them and the ships disappeared from the Tyne, trade declined. Messrs Baynes and Lyons finally closed the shop and left arm in arm in July 1949. As the Low Town expanded up the bankside early in the 1800s Bedford Street held some of the largest and most modern shops. Lower Bedford Street saw a relative decline as the shopping centre moved north to Union Street and Saville Street.

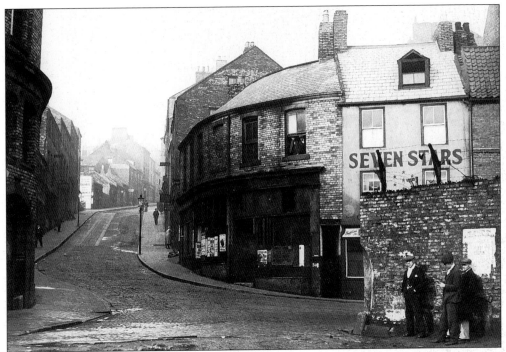

Wooden Bridge Bank, c. 1930. Long since culverted, the stream that formed Bedford Street emerged under a bridge that connected Liddell and Clive Streets. At No. 1 Wooden Bridge was the Seven Stars, a Connacher pub.

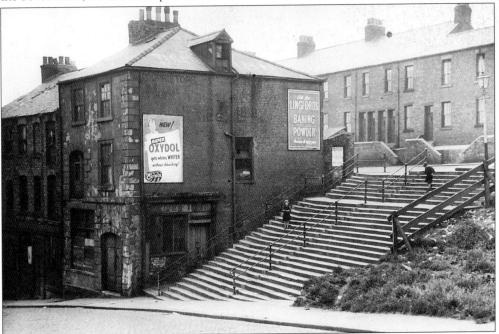

Tiger Stairs, c. 1933. Charles Connacher was licensee of the Tiger Inn, at the foot of the stairs, around 1896. Soon he held a number of pubs, was active in sports and charities, and a Councillor. He died in a road accident in 1911.

Staggie's, 1933. The Stagg family tagarine shops were well known. Dealing in a wide range of second-hand goods, this one was on the corner of Union Street and Bedford Street.

Bedford Street, c. 1910. Isaac Black built his tailor's shop at the corner of Saville Street in 1900. He founded the Boot & Shoe Fund for poor children. The boots were marked, and the police watched for them in pawnshops.

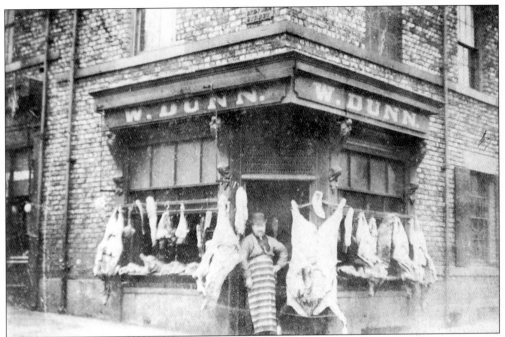

Saville Street, c. 1890. William Dunn had a prime site at the corner of Bedford Street, established by 1871. He retired in 1892, but his sons continued in the trade, with shops in Rudyerd Street and Borough Road.

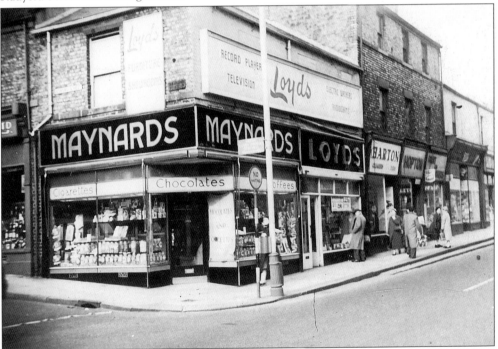

Saville Street, 1960. After a short spell as Smart & Co.'s millinery, William Dunn's shop became a branch of the confectionery chain, Maynard's. To the right are Hopton's the fruiterers, and a branch of Boots.

Gas Showroom, 1946. Founded against opposition from the whale oil lobby, the North Shields Gas Company leased part of the Low Lights on 11 April 1820. In 1913 they opened this building, with a high pressure lamp in the tower.

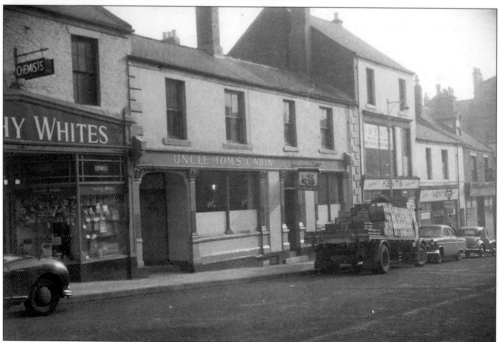

Uncle Tom's Cabin, 1960. The pub may have been known as the Railway Tavern, but became Uncle Tom's Vaults when taken over by Henry Aynsley around 1854. Harriet Beecher Stowe's book was then an international sensation.

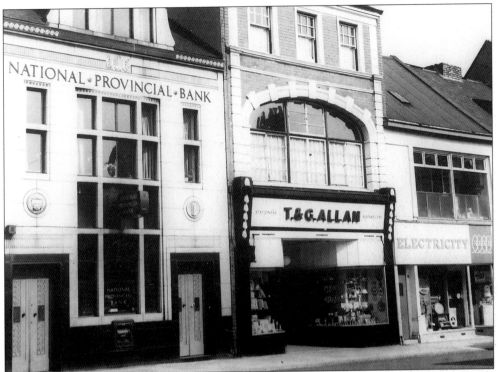

Bedford Street, c. 1967. When they took over Pearey's hardware store in 1939, the stationers T. & G. Allan fulfilled an old ambition, although the family had been connected with the town for over 75 years. (See also p. 119).

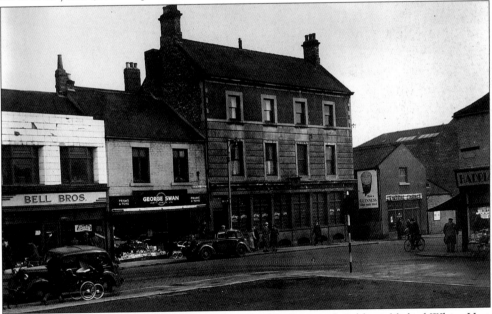

Bedford Street, February 1954. Seen over the site of Joplings is the old-established White Hart Hotel. George Swan began as a blacksmith in 1894, and diversified into bicycles and radio. Bell Bros' main shop was at the corner of Wellington Street.

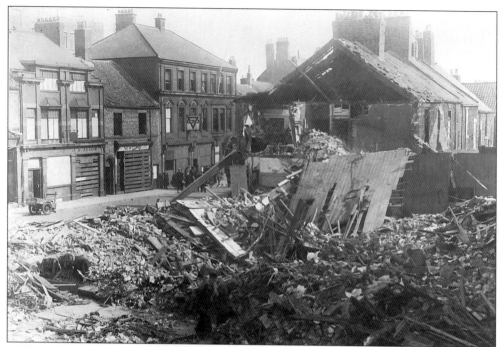

Bedford Street, 1941. The corner of West Percy Street was bombed on the night of 9 April 1941. The windows of Lloyds Bank, Ayton's and Newtons have been blown out, but the Y.M.C.A. seems almost undamaged.

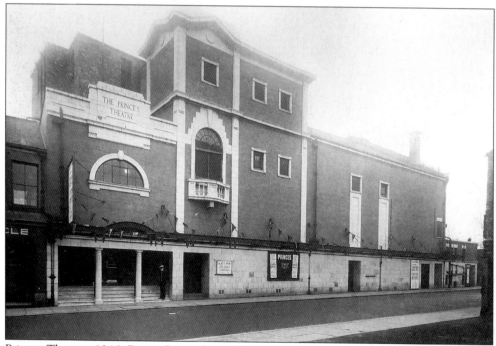

Princes Theatre, 1946. Dixon Scott planned his dream theatre in Russell Street for ten years. Hailed as the last word in cinema design, it opened on 7 October 1929. The Gaumont British chain took it over in 1931.

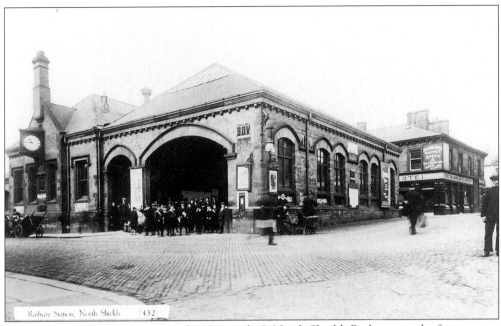

Railway Station, c. 1905. In 1839 the Newcastle & North Shields Railway was the first to carry passengers on Tyneside. The line was extended to Tynemouth in 1847. It was the first to electrify, in 1904.

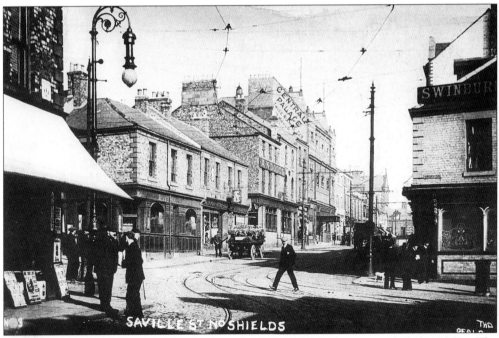

Saville Street West, c. 1920. The land south of the railway lay open until the 1860s. The Central Palace was built as the Oddfellows Hall in 1865, but is better remembered as the Comedy Cinema. It closed in 1958.

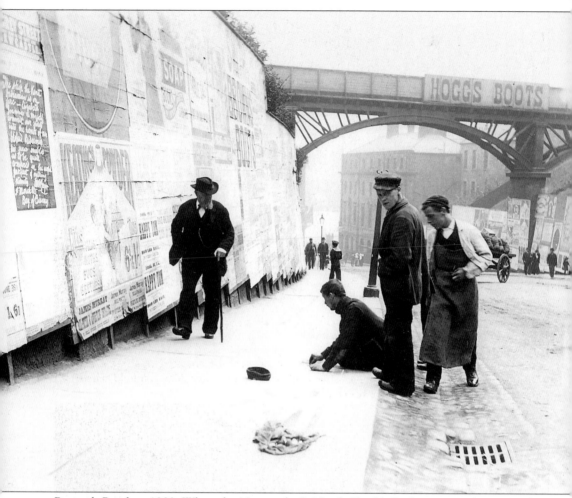

Borough Road, c. 1900. When the Newcastle & North Shields Railway opened in 1839 they realised that there was no obvious way from their terminus to the ferry landings near New Quay. Accordingly they dug the New Cut down through the Ropery Banks and installed a ticket office at the bottom. Non-passengers had to pay a toll. To restore a right of way along the bank top, the Company built a timber bridge. It was replaced with a steel structure in 1937, on condition that the Council took it over. When Tynemouth was incorporated in 1949 the New Cut became Borough Road. This photograph was certainly taken before 1908, as there is no clock on the Sailors' Home, in the distance. The advertisement for Hogg's Boots refers to an old-established family of leather workers. The best known was John Robert Hogg, a County Councillor and mainstay of the Cycle Track, the Howard Hall, and the Temperance movement.

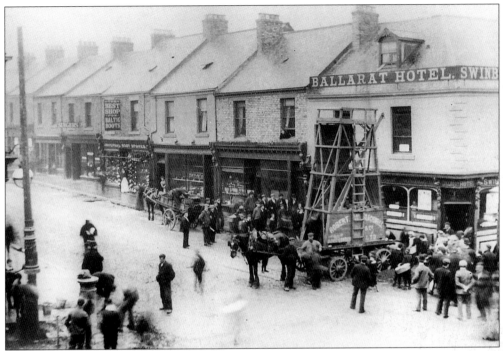

Saville Street West, c. 1900. The mobile crane appears to be raising a tram standard into position. The Ballarat Hotel was probably named after the Australian goldfield where the publican, T.J. Dodds, spent part of his youth.

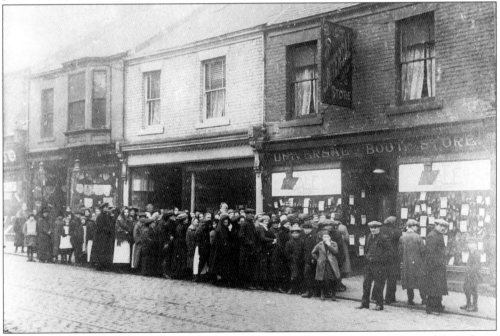

Saville Street West, c. 1920. At the far side of the queue for Mr Noton's Universal Boot Store sale, the pale coloured building is J.W. Hoggarth's White House Music Stores. To the left is Robert Hastie's drapery, founded around 1909.

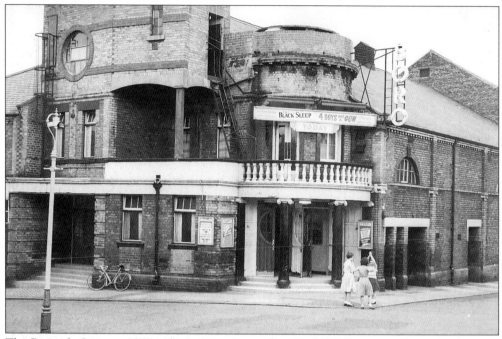

The Borough Cinema, 1957. Alvo's Circus opened on Rudyerd Street in 1901. It became the Borough Theatre in 1902. The Black Bros rebuilt it, after it burned down in 1910. The last film shown at the Boro' was *The Black Sleep*.

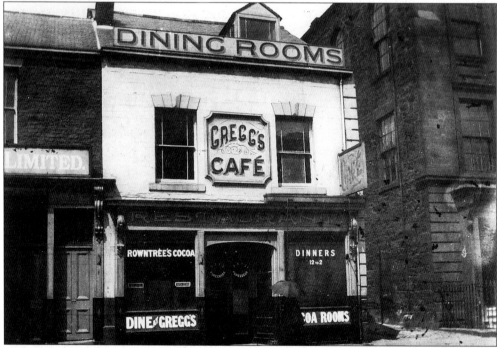

Tramway House, June 1899. Harry Gregg (later Sir Henry) took over Kirkwood's drapery as the first of his cafes in 1887. The building was much enlarged shortly after the photograph was taken.

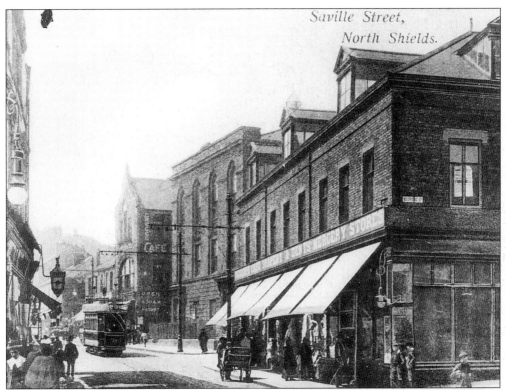

Saville Street, c. 1905. The new Tramway House cafe stands next to the Primitive Methodist chapel. At the corner of Bedford Street is Heslop's Cash Drapery, which gradually grew to occupy all the shops to Little Bedford Street in the 1890s.

Heslop's Drapery, 1909. Standing on the railing to the left is the figure of Farmer Hayseed, whose letters to the newspaper, lavishing praise on Heslop's, formed the Christmas advertising campaign.

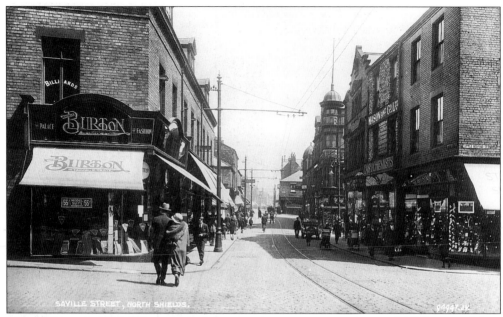

Saville Street, c. 1925. When Heslop's business began to contract, around 1920, part of their store was taken as a branch of the Burton's tailoring chain. As usual, they opened a billiard room above.

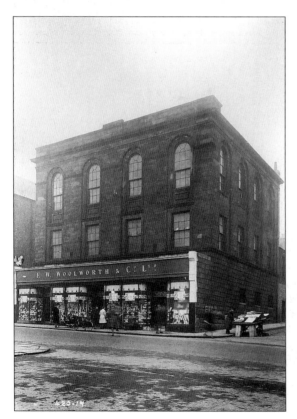

Saville Street, 1946. The Primitive Methodists first met in the town on Ranters Bank, but when the congregation grew they moved to a new church in the town centre in March 1861. It was sold to Woolworths, who opened on 13 September 1930.

Bath & Wash-house, c. 1900. The Council decided to provide public bathing and laundry facilities in 1854. The building by Church Way had its last customer on 30 June 1936. She was Mrs Maltby who had been a regular for 40 years.

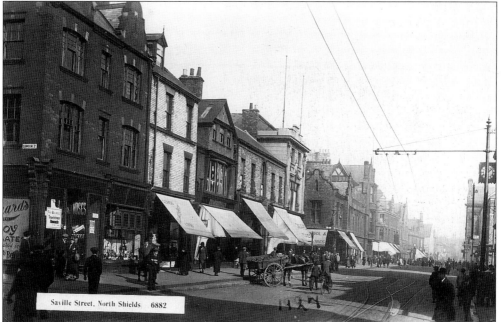

Saville Street, c. 1926. At the corner of Saville Street was Vose's confectionery shop, here advertising their imminent move to Bedford Street. Beyond the cart is Saville Chambers, with Bon Marche and Mr Bertrand's dentists surgery.

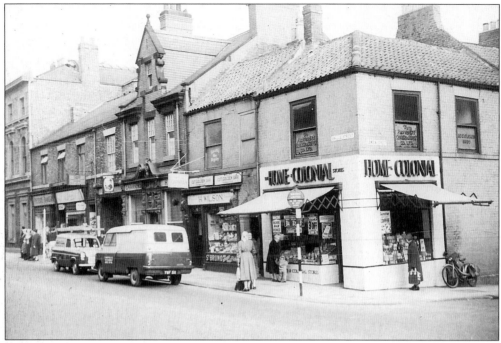

Saville Street, 1960. Before the Garrick's Head took over the corner of Camden Street it was held by the Home & Colonial grocery chain, and for many years before that by the Maypole Dairy Company.

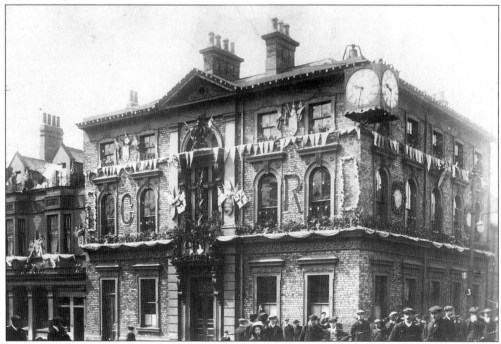

Central Library, 22 June 1911. The decorations are for the Coronation of George V. The building began life as the Mechanics' Institute in 1858, and amalgamated with the Literary and Philosophical Society collection to become the first Free Library on Tyneside in January 1870.

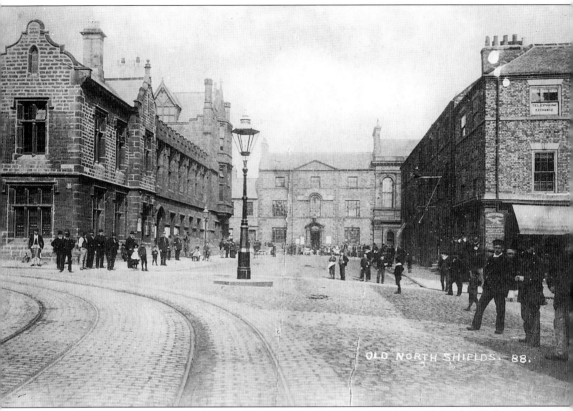

Albion Block, c. 1880. When the town centre was open land it was owned by the Earls of Carlisle, the Howards of Naworth. They sold it to John Wright in 1796 and he laid out the streets. Finding himself unable to develop eastwards, he built his mansion on Norfolk Street, looking down Saville Street. After his death in 1806 the house became the Albion Hotel. The lack of an easy passage to the East End rankled with the townsfolk, but the Council was unable to gain possession of the land until 1884. Then they were able to break through to Charlotte Street. The presence of tram lines, and the telephone exchange sign in the upper right window, suggest a date after the summer of 1880. Opposite is the building designed by John Dobson for the North Shields Commissioners in 1844. The Commission was appointed to govern the town in 1828, and was replaced by the Borough Council in 1849. They built the police station next door, and in 1865 converted the Athenaeum, at the corner, into a police court. Meanwhile the United Methodist church had been built in Howard Street. The Post Office Buildings opened between the church and the corner in 1867. (See also p. 98).

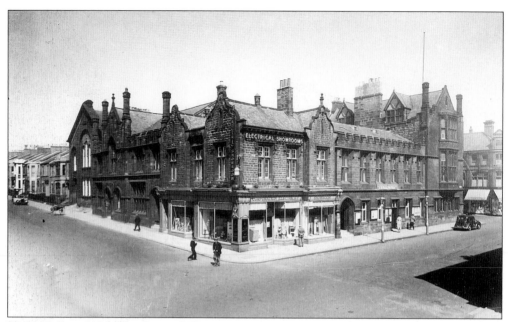

Town Hall, c. 1935. The Council Electricity Department opened a showroom to demonstrate household appliances in 1930. By the end of the year they had 1,500 irons on hire. The building was restored at the end of the Second World War.

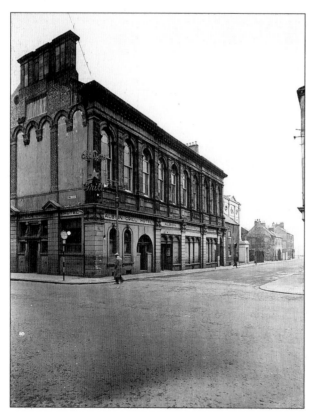

Albion Assembly Rooms, 1956. Part of the Albion Hotel, founded in 1853. A venue for social functions, it also served as a cinema, skating rink, and dance hall. It burned down in 1985.

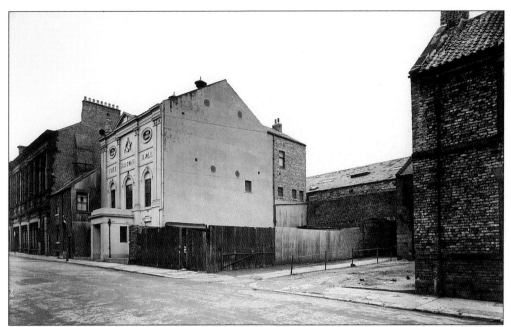

Norfolk Street, 1956. The United Presbyterian church was descended from the Ropery Banks congregation, which moved here in 1821. When they opened the Northumberland Square church in 1858, the site became the Masonic Hall. The founder of St Columba's Church in Northumberland Square left Chapel Stairs for this building. (See also p. 44).

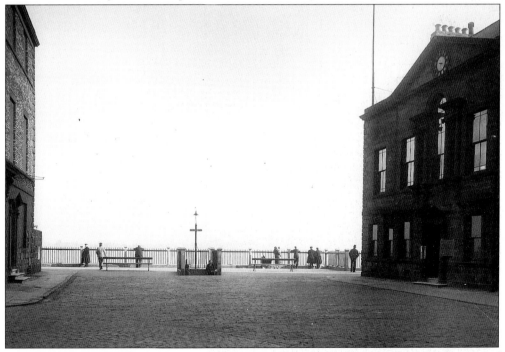

Harbour View, 1928. The Literary and Philosophical Society built their library at the foot of Howard Street in 1806. It is better remembered as the home of Joseph Robinson's shipping company, the Stag Line, founded around 1846 and the last of the North Shields based fleets.

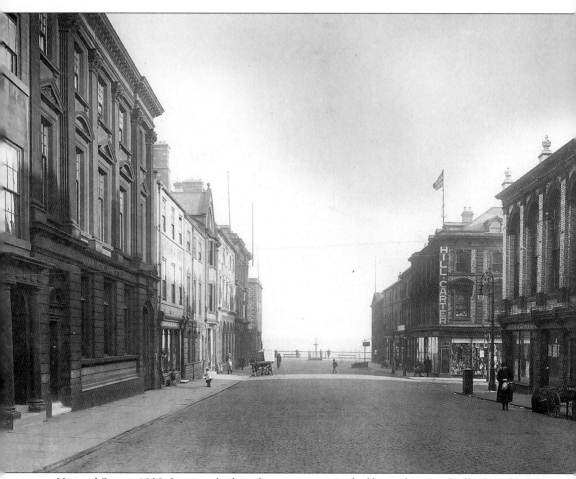

Howard Street, 1928. In its early days the street consisted of large shops and offices at the river end with smaller houses, often occupied by sea captains and 'gentlemen' at the Northumberland Square end. The bank to the left was built for Hodgkin, Barnett, Pease & Spence, a Quaker company founded in 1859. Opposite is Bishopgate House, founded as the Royal Assembly Rooms in 1877, on the site of the old theatre. During the 1930s it was used as a training centre for the unemployed. Hill Carter began life as Dennis Hill's drapery in 1825. Down the years he expanded into upholstery and carpeting, taking over the neighbouring shops along Union Street. The resulting department store developed a high reputation in the area, and many of their well-trained staff went on to found their own businesses. In 1898 Hill & Company of North Shields, Newcastle and Sunderland merged with Carter & Co. of Stockton and West Hartlepool, to become one of the largest clothing and furnishing groups in the region. This building was demolished in 1988.

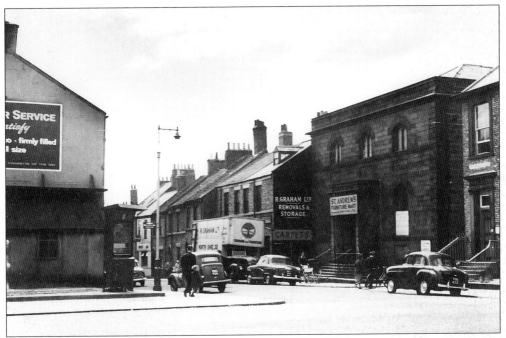

Camden Street, c. 1957. Following a feud in the Scotch Church some Presbyterians opened St Andrew's church on 15 February 1818. Soon afterwards they took a Congregational minister. The church closed in 1947, and became a furniture warehouse.

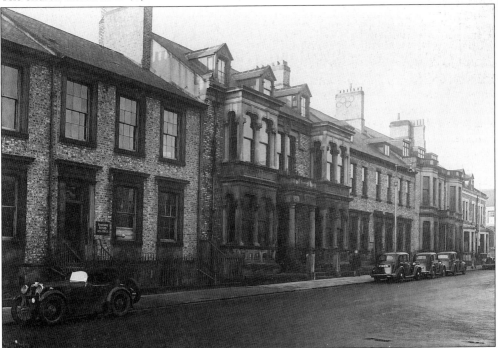

Northumberland Square, 1946. The building in the centre, on Camden Street, opened on 30 March 1878 as the North Shields Club for gentlemen. It was taken over by the Board of Guardians in 1904.

Northumberland Square, 1946. George Wakefield's mansion was the first on the Square, in 1789. Its construction broke him, and for some time there were no other houses. However, the stone was re-used to build up the north side by 1816. The houses on the east side, including the top of Norfolk Street, were mostly early Victorian. On the west side there were still builders' yards well into the middle of the century. The gardens in the centre were railed, and each of the householders held a key to the gates, to keep the grounds private. Before the building of the Beacon Centre, the Square would have been very familiar to people from a wide area. Until 1972 it was a transport centre for North Shields, as the buses congregated around the gardens.

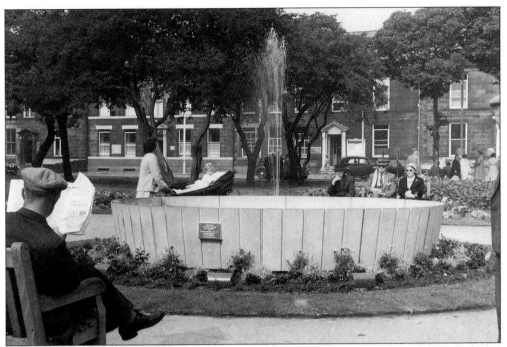

Northumberland Square, 1959. Retiring from the Council after 35 years, Ald. Richard Irvin decided to present a fountain to the town. Coloured lights below the glass well reflected off the jets of water. It was unveiled on 11 September 1959.

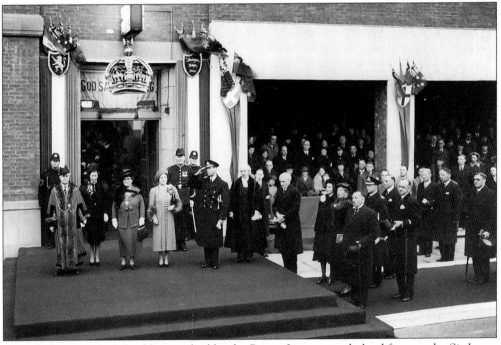

Church Way, 1939. A fund bequeathed by the Prince Line owner helped finance the Sir James Knott Youth Centre. Built behind the Y.M.C.A., it was intended for all youth groups in the Borough. George VI visited on 21 February.

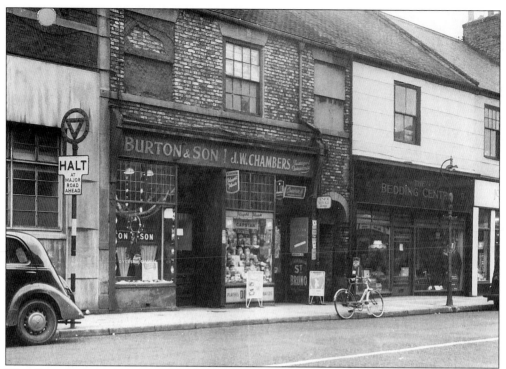

West Percy Street, 1958. Around the corner from the Youth Centre, John William Chambers bought a newsagents around 1943. D. Burton was a pioneer of dry cleaning in 1880. The Chambers family bought his shop around 1960, and Graham's Bedding Centre in 1977.

Old Hundred, c. 1895. To the left is Robert Potts' Victoria Inn, previously No. 100 Church Way. His sister bought the Angel Inn on Albion Road, to the right, in 1865. Together they became the Old Hundred Inn.

Christ Church, c. 1910. The church opened in 1668 and a number of later additions were made, including the tower in 1786. The statue in the churchyard was erected to the memory of Dr Andrew Trotter in 1836.

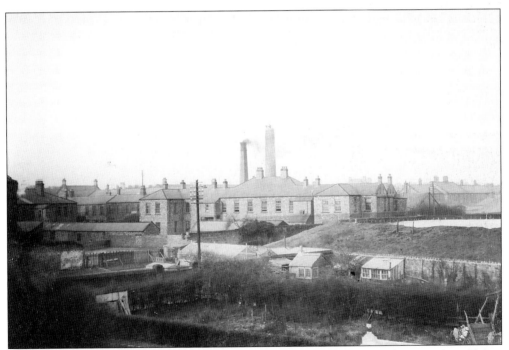

Preston Hospital, c. 1930. In its earliest years the hospital had been the Poor Law Union Workhouse. By 1890 the complex covered a huge site north of Christ Church. To the right is one of the reservoirs at Brock Farm.

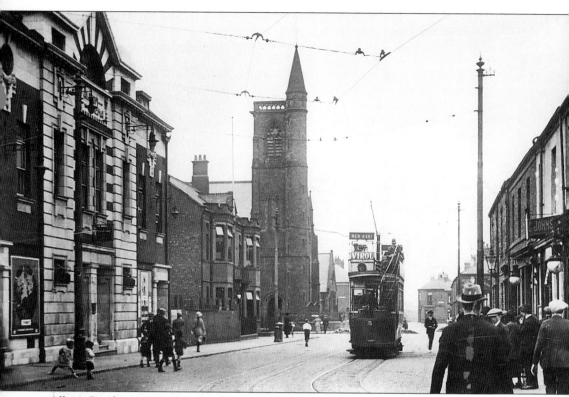

Albion Road, c. 1920. The white-fronted building was the small but luxurious Albion Cinema. Designed by local architect William Stockdale, it seems not to have included a planned glass and iron verandah over the pavement. The open space beyond was taken up by the Masonic Hall, approved in 1926. Next to the Memorial Methodist church is the Conservative Club, built in 1902 to replace a building on Tyne Street. In the distance the road to Tynemouth Village divides. Originally it passed north of the Linskill's Tynemouth Lodge Estate, but during the Napoleonic Wars a more direct route was cut along the north edge of the developing town.

Eight

Public Transport

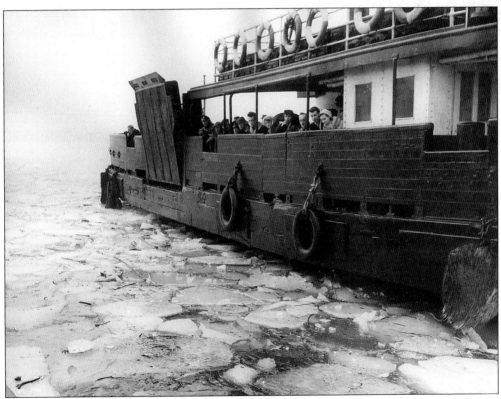

Shields Ferry, March 1963. To such traditional hazards to navigation as fog and a crowded river, this terrible winter added ice floes.

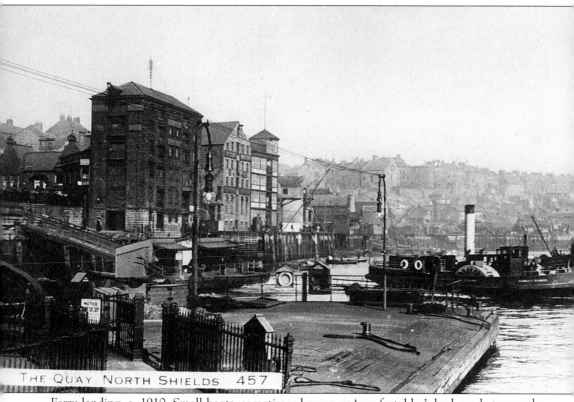

THE QUAY NORTH SHIELDS 457

Ferry landing, c. 1910. Small boats, sometimes known as 'comfortables', had run between the harbour towns since the fourteenth century, but the first steamships on the route were operated by the North & South Shields Ferry Company from July 1830. The Penny Ferries used the Market Places route. In 1847 the Direct Ferry, or Ha'penny Dodger ran straight across the river. The Whitehill Point to Penny Pie Stairs route began in 1856. The Tyne Improvement Commission took over the harbour routes in 1863, and continued in operation until they handed over to the Passenger Transport Executive in 1972. In the intervening period they had built 13 boats. Landings at New Quay and Clive Street served the cross-river vessels and those which sailed the length of the river. Small boats would carry passengers out to the North Sea and coastal ferries. In the background is the *Collingwood*, built in 1896. The dark building at the quayside was Peter Brown's biscuit factory, which burned down in 1932.

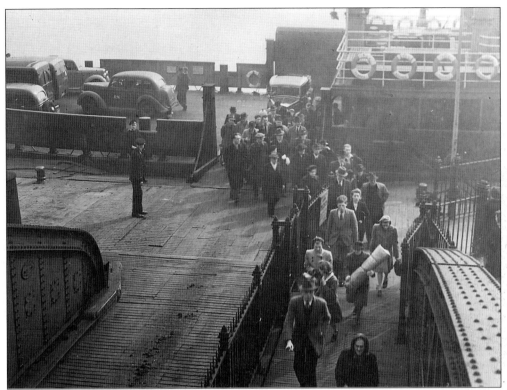

Penny Ferry, April 1946. The vehicle ferries *Northumberland, Tynemouth* and *Northumbrian* were built in 1895, 1925 and 1929 respectively. Before the Tyne Tunnel they were the only way to avoid the long journey via Newcastle.

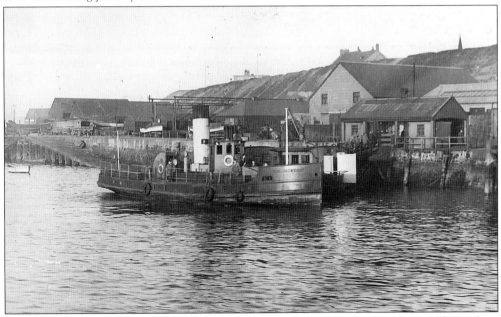

Ha'penny Dodger, April 1946. The little *Collingwood*, seen at the South Shields landing, continued the Direct Ferry route through the 1950s, until it was deemed to be uneconomic.

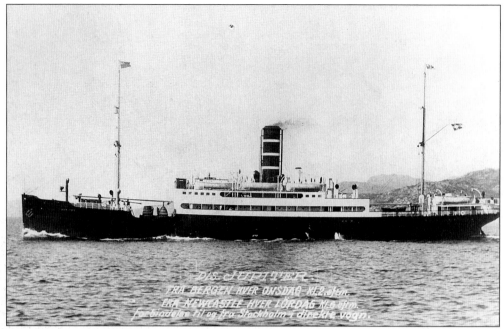

Bergen Ferry, c. 1920. The Bergen Steamship Company celebrated their centenary in 1951, but for the mailship *Jupiter* it was just another working day. She regularly sailed into the Tyne from 1916-1953.

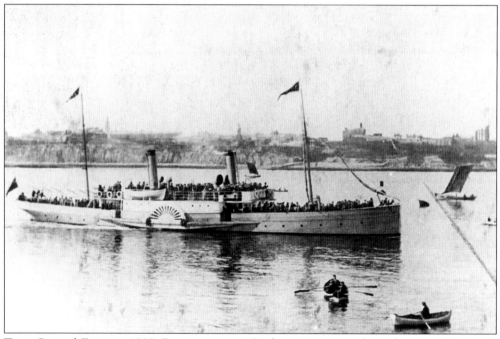

Tyne General Ferry, c. 1900. Beginning in 1859 the company ran boats between Newcastle Quay and the North Pier. Usually they carried workmen, but *Siren* also carried trippers along the coast. They ceased in 1908.

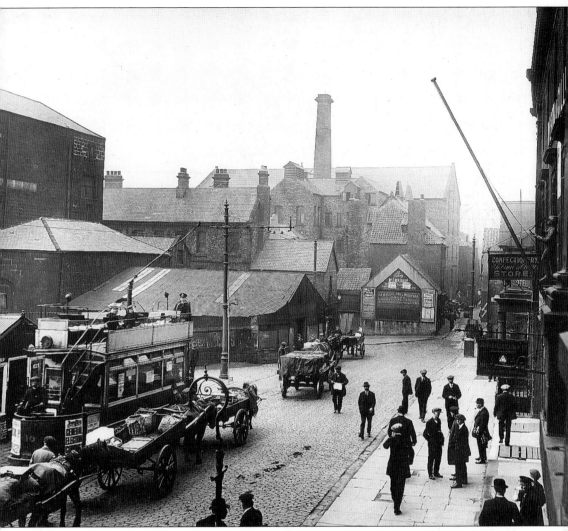

Tynemouth & District Electric Traction Co., c. 1920. The first horse tramway in North Shields opened in 1880, running between Camden Street and the Grand Parade at Tynemouth. It went bankrupt the following year, to be replaced in 1883 by the steam trams of North Shields & District Tramways. They also failed in 1886, but the line was reopened by North Shields & Tynemouth District Tramways in 1890. British Electric Traction set up their local subsidiary in 1899, and developed a route from New Quay to Whitley Village. The service opened on 18 March 1901. In 1904 the track was extended to the Links at Whitley Bay. The last tram ran on the evening of 4 August 1931, by that time they were travelling alternately with motor omnibuses.

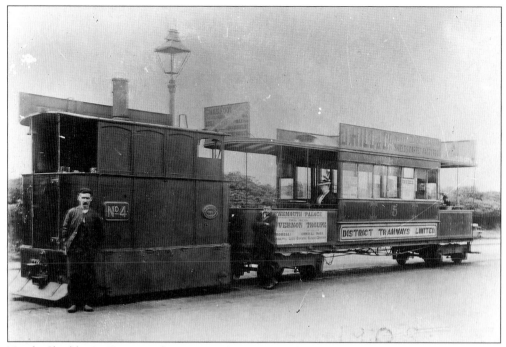

North Shields & Tynemouth District Tramways Ltd, c. 1898. The passenger car carries advertisements for D. Hill's carpeting, Tynemouth Palace, and Foot's carriage works at Preston. The latter built casings for the locomotives.

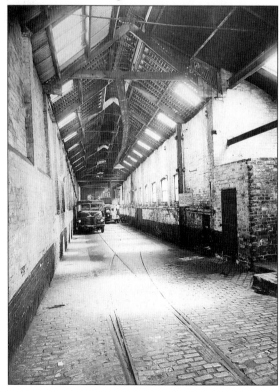

Tram shed, 1957. During the Second World War the 1884 shed at Suez Street was used by the National Fire Service. Later it housed the police, then the Ambulance and Auxiliary Fire Services, until 1959.

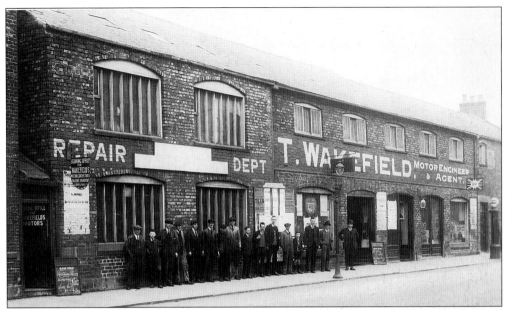

Wakefield's Garage, c. 1930. Thomas Wakefield started in business as a blacksmith and cab owner. When the Coast Road opened in 1927 he started a bus company. The board offers a 6/- return to Rothbury Races.

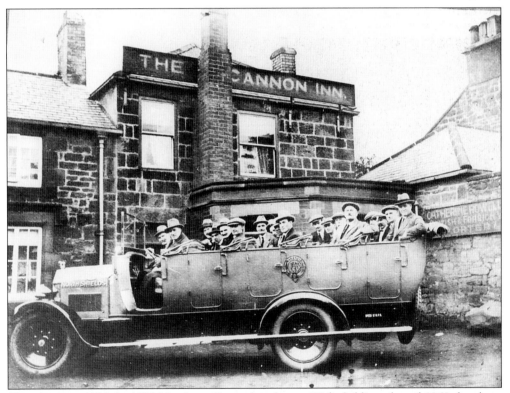

Charabanc, c. 1930. In 1929 Northern General took over Wakefield's and until 1969 they kept the name for the coach fleet. This group has parked at the Cannon Inn, Earsdon.

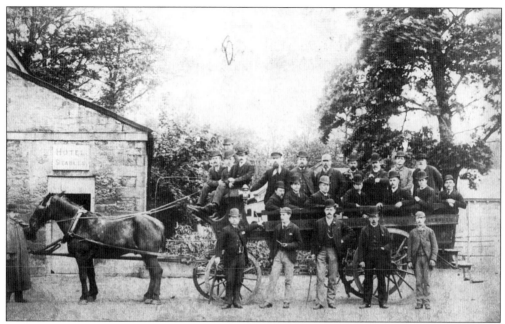

Charabanc, c. 1890. Publican George Fogg opened a livery stable at King Street in 1889. There he had an undertaking business, ran a horse bus, and hired out vehicles.

New Quay, 1957. When Northern General sold their buses to the Transport Holding Company in 1967, the local vehicles adopted the Tynemouth fleet name.

Nine

East End

Church Street, c. 1900. An old man sells windmills and other children's novelties in this street which once led to Low Meeting House Stairs, and a Dissenting chapel on the bankside below. Here the Marquis of Granby Inn and the Burton House beerhouse are at the end of the street.

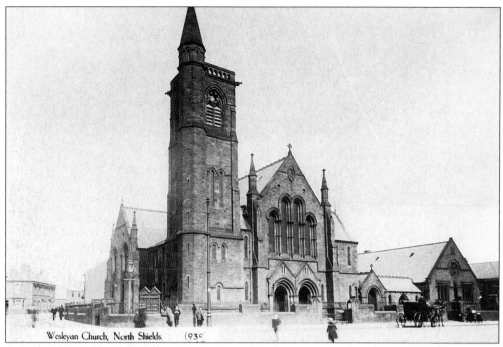

Wesleyan Church, North Shields. (930

Memorial Methodist church, c. 1905. Joseph Robinson, of the Stag Line, built the church at Brock Farm in memory of his daughter, Elizabeth Amy. He died shortly before the Howard Street Wesleyans opened it on 19 April 1891. The old chapel became the Howard Hall.

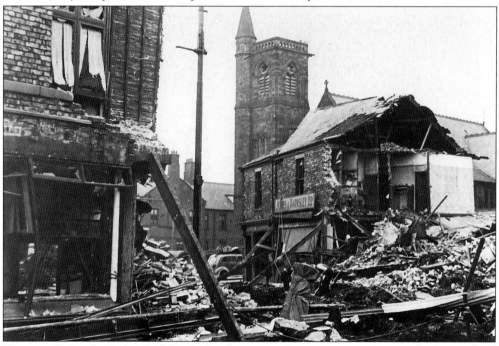

Tynemouth Road, 10 April 1941. In the first air raid to cause casualties in the Borough of Tynemouth, thirty-three high explosive bombs were dropped. One, in Brandling Terrace, collapsed the shops on the main road.

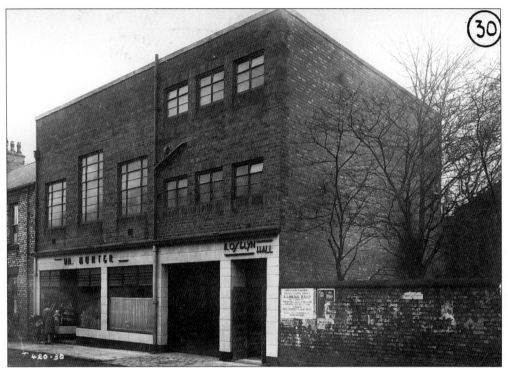

Roselyn Hall, 1946. William Hunter's chain of shops started with a small bakery in Lawson Street. In 1938 he opened his assembly rooms in Stephenson Street.

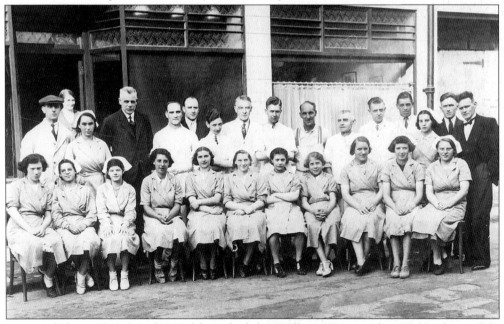

Hunter's bakery, 1938. Standing 3rd from the left is William Hunter; 4th is Mr Monkman; 7th, Jim Hunter; 9th, Mr Lattimer; 11th, Lawton Hunter; and Mr Mercer in the wing collar. Seated are, 3rd, Sylvia Upen; 7th, Peggy Burns; 9th, Ina Davidson; 10th, Doris Smith; 11th, Irene Shermer.

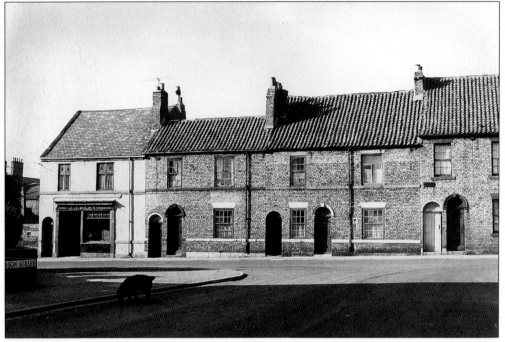

Stephenson Street, 16 September 1962. John J. Riley was a confectioner and boot repairer who moved from West Percy Street around 1925. From 1934 Florence Riley held the shop at No. 150 Stephenson Street.

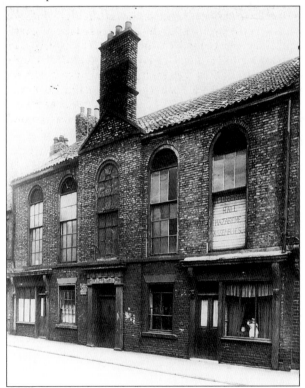

Central Hall, 1933. Built at the bottom of Stephenson Street as an assembly room, it was taken over by the Baptist church in 1799. From 1866 it was the Temperance Hall, and, after alterations in 1886, the Central Hall.

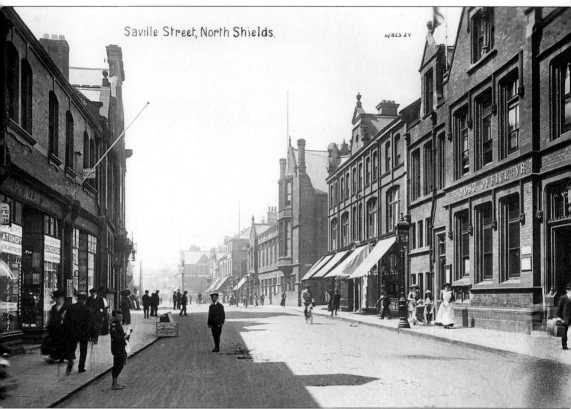

Saville Street, North Shields.

Charlotte Street, c. 1910. On the line of one of the roperies which once blocked the eastward development of the town centre, the Council opened the Indoor Market in 1888. Opposite, to the right, is the Post Office. The foundation stone was laid by veteran postmaster John Humble on 9 April 1889. By the time of the photograph the Albion Question had been solved, opening the way into the East End. (See also p. 97). Around the same time Wellington Chambers opened opposite the Athenaeum on Norfolk Street. Ralph Allan, late of Newcastle, had been a stationer in Tyne Street from the 1860s. The shop to the left, however, was opened around 1900; a sign that the main shopping area was moving away from the riverside streets.

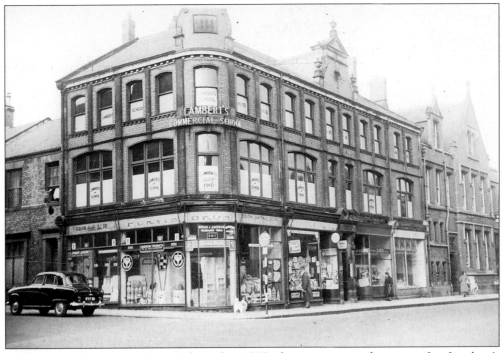

Wellington Chambers, 1960. Below the 1898 date-stone are the signs for Lambert's Commercial School. For some fifty years, under Frederick Lambert, it offered courses in shorthand, typing and office procedures. Below it is Purvis Bros, the ironmongers.

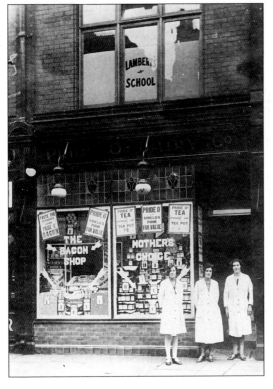

Pride O'Dairy, 1930. Part of a South Shields company, the shop was at Saville Street around 1929-1932. Standing on the left is fourteen-year-old Frances Dale.

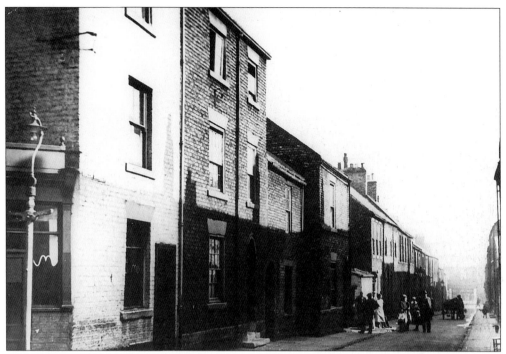

Queen Street, 1933. The street was laid out in 1784, but the site to the left may have been vacant until 1807. It includes the late Lord Nelson beerhouse. The bay window at Venteman's bakery has been replaced with lighter bricks.

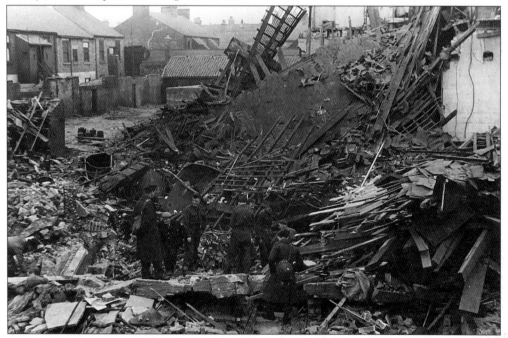

Wilkinson's shelter, 4 May 1941. W.A. Wilkinson's lemonade factory on King Street took a direct hit, sending the machinery crashing down onto over one hundred people taking refuge in the basement. It was the town's worst wartime disaster.

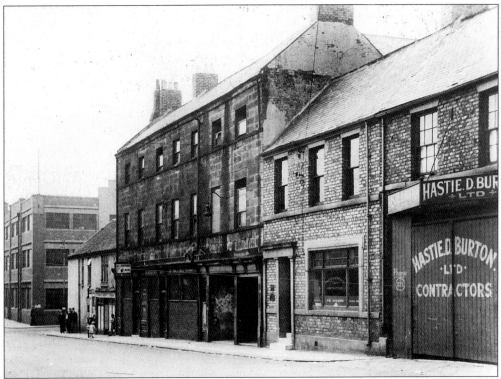

King Street, c. 1950. The three-storey building in the centre includes the Old George Tavern, named after assembly rooms next door, which became Fogg's Livery Stables. From 1909 it also held the Gaiety Cinema.

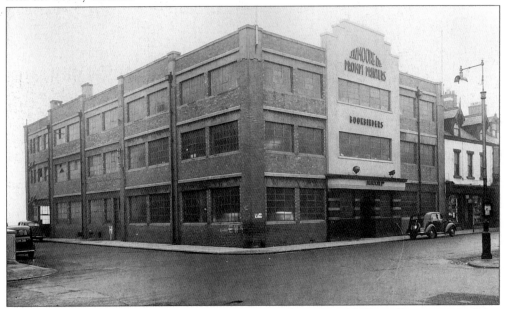

Charlotte Street, 1946. J.W. Moore was apprenticed to the old Tyne Street printer John Philipson and went into business for himself around 1897. His 1920 printing works was one of the most prominent on Tyneside.

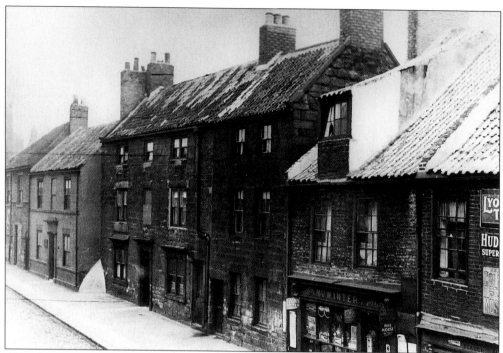

Church Street, 1933. North Shields & Tynemouth Dispensary, second from the left, was founded in 1801 to provide free medical treatment to the poor. The charity continued into the 1940s. These properties backed onto Dockwray Square.

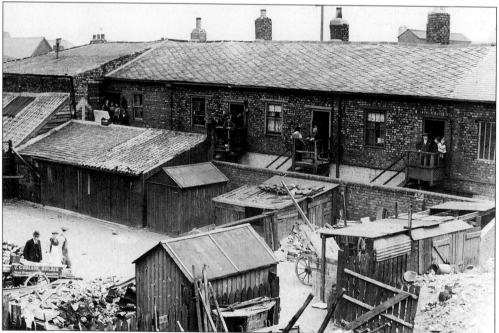

Fawcus Buildings, 1933. The cottages were presumably built for the workers at Pow & Fawcus' chain and anchor works, Reed Street. Their smoke was a source of annoyance to their neighbours in Dockwray Square. The firm left the town around 1875.

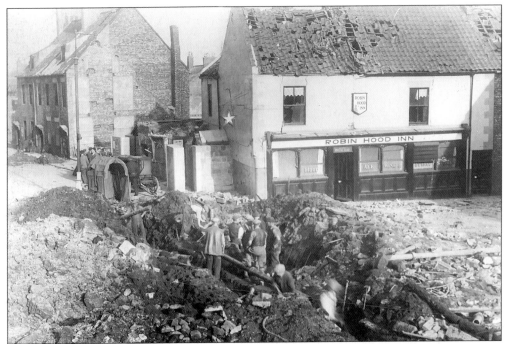

Bird Street, 2 October 1941. This bomb killed a policeman behind the blast-wall at the corner of Beacon Street, but the Robin Hood Inn survived until 1957. It was demolished when the Corvette was completed.

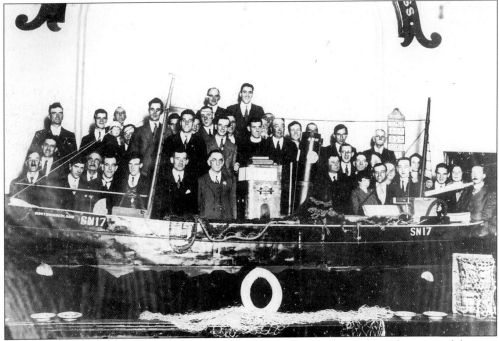

Northumberland Street Mission, 23 August 1931. Revd C.J. Steley and his choir are celebrating the Harvest of the Sea thanksgiving. To the left of the wheelhouse are Mr Shield, and Mr Heather, who built the model .

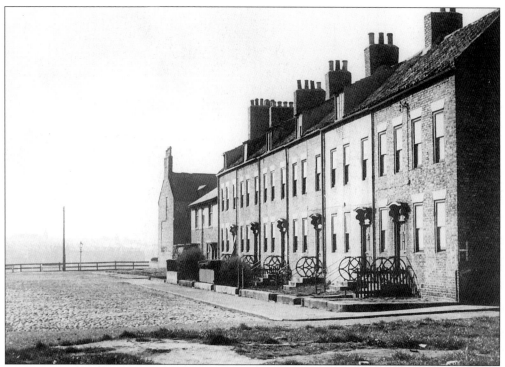

Toll Square, around 1958. Ex-Parliamentary soldier and prosperous draper Edward Toll bought much of the Bankhead property in 1667. The Square was named in his honour when his great-grandson developed the land in the 1760s.

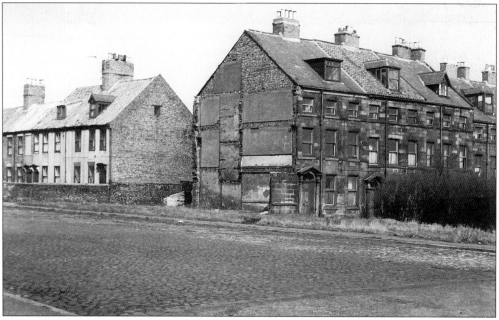

Tyne Terrace, c. 1958. John Hutchinson built the houses overlooking the river, possibly the first in the Dockwray development. Situated to the right of Toll Square, they were known as Hutchinson's Buildings until 1876, when the residents petitioned for the new name.

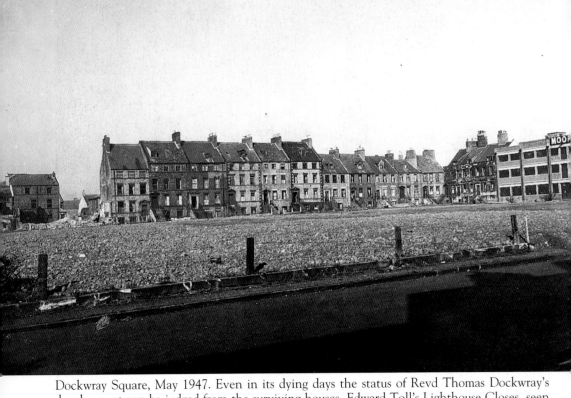

Dockwray Square, May 1947. Even in its dying days the status of Revd Thomas Dockwray's development can be judged from the surviving houses. Edward Toll's Lighthouse Closes, seen here, passed to his grand-daughter Elizabeth. She married Josias Dockwray, who was connected with the extensive local salt industry. Their son was the Vicar of Stamfordham, who began to lay out his mother's property in 1763, beginning with Dockwray Square, which was completed by 1787. This and Toll Square were the first major developments laid out on the Bankhead above the original North Shields. Even as the houses were being constructed the residents formed themselves into a Trust to keep the railed gardens in the centre of the Square free from building. They also urged that the south side be kept open. Allegedly, many were shipowners, who liked to be able to watch for their vessels entering the Tyne. For much of its life the Square was considered the natural home of the town's prominent doctors and lawyers. As they moved to more fashionable areas their houses became tenemented. In February 1956 the Council declared the Square unfit for habitation, and decided that demolition was the most satisfactory means of dealing with the problem.

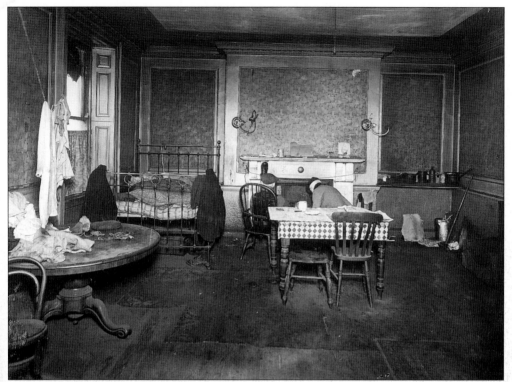

No. 42 Dockwray Square, 1947. The great size of the houses had by this time become a problem for the people prepared to live in them. This, and the changes in building fashions of the 1950s and '60s, led to the destruction of the Square.

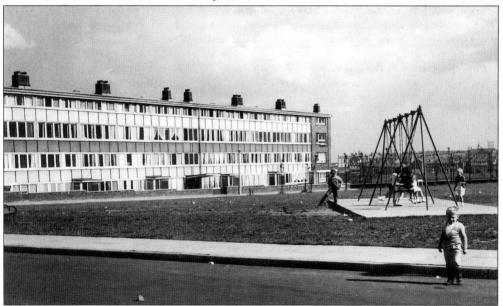

Dockwray Square, 15 August 1963. Multi-storey flats around a communal recreational area were very much part of the 1960s vision for public housing. It was not to last and by the mid 1970s the flats were in decay. The 1980s saw them replaced with more traditional housing.

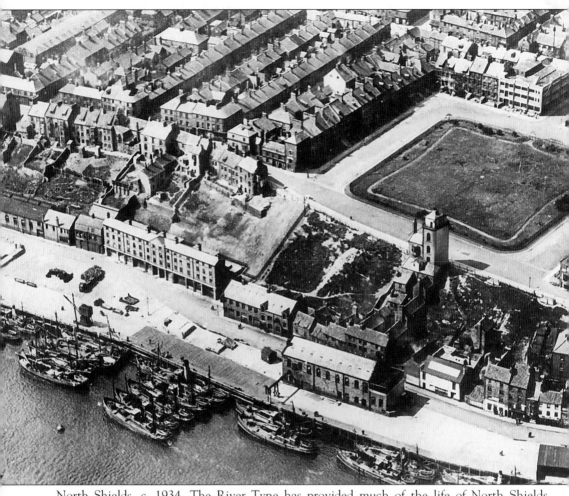

North Shields, c. 1934. The River Tyne has provided much of the life of North Shields, whether from the ships in the harbour, or through support industries. Steam fishing boats are crowded along the Western Quay, close to the old ice factory. The Northern Counties Ice Company had persuaded Tynemouth Borough Council to build an extension to Union Quay in 1895. This did not, of course, replace older methods of preserving fish, such as the nearby white-fronted Miller's smokehouse. Many of the original houses had been reduced to their foundations, as the townsfolk were being moved out to the Ridges Estate. Below Tyne Street, however, the Council had opened a block of flats in 1928, to rehouse the people of the East End. In the 1780s Dockwray Square had been a prestigious development, and to the left, Tyne Street held some of the best and largest shops in the town. In the inter-war years the Square was no longer the exclusive area it had been. Some of the houses had even been demolished to build Moore's printing works. All the Banktop was flattened in the post-War housing drive. After the hastily regretted flats of the 1960s had been cleared away, in the 1980s, Dockwray Square became a prestigious development.